THE HANDBOOK OF
HEBREW CALLIGRAPHY

THE HANDBOOK OF

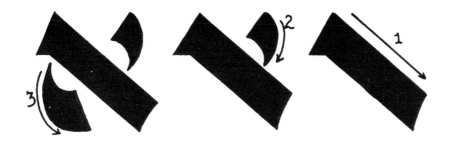

H E B R E W
CALLIGRAPHY

Cara Goldberg Marks

JASON ARONSON INC.

Northvale, New Jersey London

10 9 8 7 6 5 4 3 2 1

Design by Ernie Haim

Library of Congress Cataloging-in-Publication Data
Marks, Cara Goldberg.
 The handbook of Hebrew calligraphy / Cara Goldberg Marks.
 p. cm.
 ISBN 0-87668-798-2
 1. Calligraphy, Hebrew. I. Title.
NK3636.A3M37 1990
745.6'19924—dc20 90-728
 CIP

Manufactured in the United States of America. Jason Aronson Inc. offers books
and cassettes. For information and catalog write to Jason Aronson Inc., 230
Livingston Street, Northvale, New Jersey 07647.

To the memory of my beloved grandmother, Bella Gwartzman,
who lived by the letter of the law and the spirit of the Hebrew letters;
may her memory live on forever.

To the memory of my grandfather, Zaideh Leib,
who wove each day a new fabric in the cloth of life, and encrusted
it with pearls of wisdom;
may his memory live on forever.

To the memory of my grandfather, Aaron Gwartzman,
whose chapter closed too soon but whose legends continue on;
may his memory live on forever.

In honor of my grandmother, Bubby Taible,
the brightest jewel in the crown of life;
may she live forever.

CONTENTS

AUTHOR'S CONCLUDING WORDS *158*

PREFACE

Of all the alphabets in the world, the alphabet of the Jewish people is unique. From its standardization two-and-a-half millennia ago, in the days of Ezra the Scribe, until today, the Hebrew alphabet has survived in its original form.

The Jews are the only people who still speak the language their ancestors spoke 4,000 years ago, who still practice the religion taught by Abraham, and who still read and write the letters given to them by God on Mount Sinai. For the last 2,000 years, the Jewish people have been scattered to the four corners of the earth, wandering from country to country, speaking the languages of the many lands in which they stayed. Not once did they sever themselves from their past. The Jews, *Am Hasefer*, "The People of the Book," have survived burnings, beatings, drownings, torture, imprisonment, cultural and religious suppression, censorship, exile, and all attempts to annihilate them. They have suffered every abuse known to humanity, at the hands of madmen and self-proclaimed messiahs. Despite the tribulations of their history, the Jews have managed to produce a rich literary legacy. Unfortunately, little has survived their persecuted existence. The burning of books, the wiping out of Hebrew literature, was always the symbolic, angry gesture that preceded their many confrontations. Book production would reemerge sporadically throughout Jewish

history, only to suffer the humiliating defeat of renewed public burnings.

The prophets demanded that the Jews be a people dedicated to *halakhah*. It is a *halakhah* from Moses on Sinai to write on leather with ink and to rule with a reed (*Megillah* 71b). The ink had to be black, prepared according to a certain recipe; the scribes had to copy from an authentic model without changing a single stroke. No word or letter could be written from memory—the copying model had to be kept in view. The space of a hair was to be left between each letter; every letter had to be surrounded by paper on all sides. The width of a narrow consonant was to be left between each word. The width of nine consonants was to be left between each chapter. The length of three lines had to be left between each book.

It is a significant fact of Jewish history that tradition has been preferred over modernization. Jews have adhered strictly to the laws because they believe that in order to survive they must retain the traditional form.

Jewish intellectuals, immersed in the study of Torah and surrounded by a hostile world, dedicated themselves to the perpetuation of the letter of the law rather than to the design and beautification of the written word. Only recently have the Jewish people concentrated on the advancement of the Hebrew alphabet. Typographers object to the Hebrew alphabet because there is no distinction between capital and lowercase, making it difficult to differentiate the value of the letters. Typographers feel that the squareness of the letters affects the flow and meter of writing. They object to the horizontal emphasis of the letter stroke, contrary to the vertical weight of the English letter. They also feel dissatisfied with the limited selection of Hebrew typefaces, making it difficult to choose a style appropriate to a given occasion.

Instead of adapting the Hebrew alphabet to regular and artistic styles, attempts have been made to change its form. Most tries have failed because the revised letters no longer look like the traditional letter forms. In redesign, little consideration has been given to the vowel and accent marks that appear above, below, to the left, to the right, and inside the letters.

It is time to reform the Hebrew alphabet. It must not be a transformation to a new letter alphabet, which would cut modern Jews off from the ancient and rich tradition that has been preserved for two-and-a-half millennia. Instead, new styles of letters, combining the tradition of yesterday and the artistry of today, could very well succeed in bridging the past with tomorrow.

The twenty-two letters of the alphabet communicate the philosophy of a people and the basic precepts of a religion, along with the perseverance and struggle for the existence of the Jewish people. A

resolution must be made to encourage a greater and grander contribution to the legacy of a people, blending the old and the new. Hebrew has remained a constant alphabet for generations. May it remain a constant alphabet, a beacon of tradition, for a hundred and twenty more!

ACKNOWLEDGMENT

To Elizabeth Elberg, whose encouragement, generous criticism, and belief in me set me on the right path at the beginning of my commercial art studies, and whose courses at Pratt Institute set a standard for me of detailed, thoughtful study of design and color. I am grateful for the sturdy foundation that she helped me build, and for her help in showing me that success requires persistence and perseverance.

Special thanks are due my mother and my father, Dr. and Mrs. John Goldberg of Toronto, Canada, whose continuous love and support have been a great encouragement throughout my career.

To my sister Marla, who denied the world a great veterinarian but gave it an even better artist.

And to my sons, Dov, Zev, and Gurion, for their patience and love during the research and writing of this manuscript.

PART I

THE HEBREW SCRIBAL ARTS

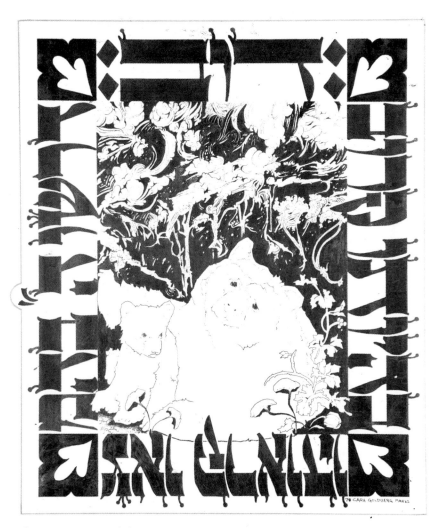

Birth announcement of the artist's oldest son. The bear theme is based on the child's name, Dov.

CHAPTER 1

THE ALPHABET

A recent awakening of cultural awareness and renewed interest in Jewish tradition have led to a revival in the Hebrew scribal arts. People are flocking to classes in Hebrew calligraphy; courses are being taught in adult education programs and scribal associations—wherever a community can fill this special need.

Modern-day calligraphers—often barely versed in English, let alone Hebraic calligraphy—have accepted the responsibility of perpetuating this particular form of Jewish heritage. Unfortunately, it is frequently a case of the blind leading the blind. Some self-proclaimed experts in the scribal arts are taking liberties: dividing words incorrectly, exaggerating and distorting letter sizes, and erroneously claiming that their work is within the boundaries of *halakhah*, the rabbinic rules. The Hebrew letters serve to draw us closer to our heritage, and it is sad that such poor artisanship is offered to beginning calligraphers, as it encourages and perpetuates errors. Properly written calligraphy should serve as the basis for rejuvenating and enriching our heritage.

In 1947, two Arab shepherds discovered the Dead Sea Scrolls in a cave near Qumran, in Palestine's northwestern region of the Dead Sea. One of the scrolls, measuring twenty-four feet in length, carried the complete text of Isaiah. The text was almost identical to the text of Isaiah used today. Since the first discovery, hundreds of caves have

been searched and eleven caves have yielded scrolls bearing selections from every book in the Hebrew Bible. The scrolls from the first cave were wrapped in leather liners and carefully sealed in ceramic jars, as if the people who placed them there were leaving on a trip. The scrolls found in other caves seemed to have been dumped in haste.

The importance of the Dead Sea Scrolls cannot be overestimated. As well as providing fresh insights into the study of the Bible, Hebrew theology, history, and liturgy, the scrolls have deepened our knowledge of ancient Hebrew inscriptions and writing. By studying the old square and cursive scripts found in the documents, we have greatly increased our understanding of today's Hebrew alphabet.

HEBREW SCRIPT IN HISTORY

Hebrew writing has enjoyed a continuity of form (see Fig. 1–1, Alphabet Family Tree). One of the earliest confirmed dates of ancient manuscripts using classic Hebrew square script is 916 B.C.E. Cursive tendencies intruded upon the formal script after 1000 B.C.E., though they did not permanently impair the square Hebrew, which was preserved through the Middle Ages and the Renaissance to the present. Hebrew writing has varied slightly from country to country, but its basic structure has remained untouched.

The square script comes from Aramaic, which had twenty-two letters and was written right to left. The name "square script" is actually a misnomer; at times the letters are oblique, while the top and bottom strokes remain parallel to each other.

Aramaic was the official language of the Babylonian, Assyrian, and Persian empires. Babylonian Jews, while maintaining solidarity as a community, adopted Aramaic as their language and as the official script of the Torah.

Ktav Ivri, the pre-Babylonian-exile script of the Jews, had highly stylized lettering, consisting of very thin downstrokes, slanting to the left. Thick lines dominated the horizontals, influencing the letter forms of the Aramaic square script. In the course of the next few centuries, the Jews developed scripts of their own. The formation of Hebrew was almost complete by the third century B.C.E. A significant development in the letters was noticeable by the second century B.C.E., and the square script was reaching its final form by the first century B.C.E. In the seventh century C.E., almost every letter of the alphabet had a top bar, while many letters had bases as well. In the original script, the strokes were not absolutely straight, but had a tendency to curve, wave, or taper. Some strokes were carried above or below the line. Half of the letters rested on their bases; the other half stood or rested against their neighbors. The weight of the horizontals gave the impression of

right-to-left continuity along the line. The letters were written within an invisible, rectangular, oblong frame, standing on one of its shorter sides. A manuscript dating from 896 C.E. shows letters written in a style that is virtually the same today. The top bars of certain letters at the left end of a line were extended to reach to the left margin, so that the edge was justified, thus making neat columns and enhancing the aesthetic nature of the page. This technique is known as *dilitation.*

Until quite recently, the classic square script remained virtually unchanged. One reason for this continuity is that the thrust of Jewish culture has been directed more toward the development of intellectual and ethical behavior than to arts and crafts. The strict code of the *sofrim* (scribes) limited the use of the *Torah Ktav* (sacred letters) to the Torah scrolls, *mezuzot, tefillin, meggilot,* and *gittin* (divorce documents). The *Torah Ktav* was a form of square script embellished with crowns on certain letters. Other letter forms, such as the Rashi script, were developed for the purpose of commentary on the Bible, since use of the sacred script for anything other than its designated purpose was considered profane. Rashi script also helped clarify where the main text ended and commentary began. Furthermore, Hebrew letters were often used by the great master scribes in their depictions of biblical scenes.

Square Hebrew, with its strong horizontals and verticals and slow curves, is a calligrapher's alphabet. It has the fine, lasting quality of generations of tradition that bridges the past and the present. Today it is used mostly for *ketubot* (wedding contracts), invitations, posters, book jackets, and in print.

Hebrew cursive is an informal script used for letters, notes, business matters, and legal documents. It is not a reproduction of the formal script as it lacks certain details, and there is a tendency to add curves and flourishes to the letters. The *Mashait script*, often erroneously called rabbinic script, was most often used for religious texts. It served as the basis for cursive and encourages calligraphers to experiment with decorating it.

At different times in history Jews adapted Hebrew script to write other languages: Arabic and Turkish (used by Karaite Jews in the Crimea), Yiddish (used by Ashkenazim), and Ladino (used by the Sephardim).

Yiddish, the international Jewish language used by Ashkenazi Jews for the past 1,000 years, was also the language of the Eastern European emigrants to Canada and the United States. Yiddish probably originated around the Middle Ages in the Rhineland. It was based on early medieval German and Hebrew. It developed as an intricate fusion of several languages—German, French, Italian, Aramaic, and Slavic—absorbing new words from the languages of the countries in which it

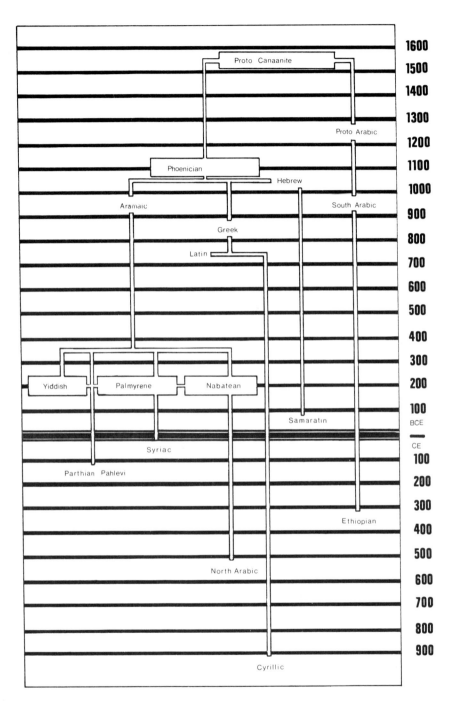

Figure 1–1 ALPHABET FAMILY TREE

was spoken. Over the centuries, Yiddish was widely used as a conversational language; spoken Yiddish varied from region to region, but written Yiddish remained fairly standard.

Yiddish characters are based on the Hebrew alphabet, with some standardized diacritics and the introduction of some letters used as vowels. For instance, *alef* א was used for the vowel sound ā; *kametz* אָ was used for the ō sound, and *ayin* ע was used for the ē sound.

Ladino, or Judezmo, was based on Castilian, spoken in fifteenth-century Spain. It became a specifically Jewish language after the Jews were expelled from Spain in 1492. The Jews continued to use Spanish dialects interspersed with words and expressions from Hebrew, particularly in religious and ethical discourses. Ladino has preserved hundreds of archaic words that are either no longer used in modern Spanish, or now have different meanings.

For several centuries, Ladino has been written with the letters of the Hebrew alphabet. From the sixteenth century onward, many Ladino books were printed in square lettering. A few diacritical signs were added to the Hebrew letters to adapt them to the needs of the Spanish language, though attempts to standardize the writing met with little success.

Compulsory education in the twentieth century, together with the devastating effects of the Holocaust, have brought about an almost fatal decline in the use of both Yiddish and Ladino. For the most part, Jews from the Yiddish- and Ladino-speaking areas of Europe who emigrated to North and South America have adopted the languages of their new countries. Furthermore, a wealth of Ladino texts was destroyed by the Nazis, while Yiddish has been hampered by the shortage of texts from earlier periods. Yiddish is spoken by certain Hasidic groups. Ladino is still used by a small minority in Israel, although few can read and write the language today.

THE ALPHABET

The order of the letters in the Hebrew alphabet is the same as the order of the letters in the North Semitic alphabet. Theologians believe that square Hebrew, the ancestor of modern Hebrew, remains unchanged in letter and order from the time of Moses.

There is no distinction between capitals and small letters, so letters are the same size at the beginning and the end of a word. All letters of the Hebrew alphabet are uniform in height with the exception of *yod* (the smallest letter), *lamed* (the tallest letter, the only ascender), *kuf*, and the final letters except for the final *mem*.

Gimel ג , *vav* ו , *zayin* ז , *yod* י , *nun* נ , and final *nun* ן are narrower in width than the other letters in the alphabet.

Five letters assume a dual form when placed at the end of a word. The five final letters, *kaf sofit* ך , *mem sofit* ם , *nun sofit* ן , *pe sofit* ף , and *tzadi sofit* ץ , are combined in the mnemonic word *menzapak*. The final forms of the letters were established during the second century c.e. when square Hebrew became fixed into its final form. Four final letters are differentiated from the regular form by tails drawn straight down instead of being bent to the left.

ץ ף ן ך

FINAL FORM

צ פ נ כ

REGULAR FORM

The current names of the letters of the alphabet and the sounds they stand for are still mainly traditional, and it has been suggested that there is a direct correlation between the names of the letters and their original shapes, that is, the letters may have been developed from representations of everyday objects. Hence: *alef* (ox), *bet* (house), *gimel,* (hump of a camel), *dalet* (door), *heh* (praying man), *vav* (hook), *zayin* (weapon), *het* (fence), *tet* (snake), *yod* (hand), *kaf* (back of head), *lamed* (ox goad), *mem* (water), *nun* (fish), *samekh* (post, prop), *ayin* (eye), *pe* (mouth), *tzadi* (fish net), *kuf* (monkey), *resh* (head), *shin* (tooth mark), *tav* (cross). The names are borrowed from Aramaic, which in turn evolved from the earlier Semitic. The order of the letters of the alphabet are recorded in Lamentations 1–4, Proverbs 31:10–31, and Psalms 25 (*kuf* is missing), 34, 111, and 112.

Like all Semitic languages, Hebrew is a consonantal alphabet. It consists of twenty-two letters, four of which are used somewhat like vowels. These four—*alef, heh, vav, yod*—are vocalic, or weak consonants that have become silent. Vowels and punctuation are indicated without changing the spelling of a word in any way because "the omission or deletion of one letter might mean the destruction of the whole world," says the Torah.

Words can neither be broken apart nor continued on the next line, as some calligraphers do with English lettering. Breaking the consonants apart forms new and smaller words. Some letters are, however, suitable for expansion: *heh* ה , *lamed* ל , *tav* ט , *dalet* ד , *kuf* ק , and *resh* ר . *Alef* and *mem* can also be expanded, but only minimally, as too much stretching will distort their forms. Expanding letters help typeset a page so both sides can be flush right and left.

The first punctuation marks to be introduced were the *sof posuk* and the *ethnacto*, the period and the colon, to indicate the end of phrases and paragraphs. Text passages were often quite lengthy, and required marks to show stops and pauses. The *dagesh*, the dot found in the middle of the letters, indicates the doubling of certain letters;

letters with a dot in the middle have a hard sound. The same letters, without a dot, have a soft sound. (See Fig. 1–2.)

Figure 1–2

The Hebrew vowel system is called the Tiberian or Masoretic system. For a time, it was in competition with the Babylonian vowel system, in which vowels (dots and dashes) are placed above the letters; traces of the Babylonian system are evident in nineteenth-century manuscripts.

In the Tiberian system, the vowels are placed underneath the letters, except in the case of the letter *vav*, which has dots either above or beside it. Hebrew has the vowel sounds ā, ă, aă, ē, ī, oi, ŏ, ū. Eighteen signs are used as *mafsikin*, pause signs. The vowels that wear the pause are called "servants," because they serve the sign of the pause. These signs are further divided into classes, according to the degree of the pause they indicate. The signs are also used as reading notes for the Torah chant, which has been preserved by tradition. Each sign has its own inflection and note called accent and punctuation marks. The accent system makes the reading of Hebrew easier. It stabilizes the vowel system and helps make the content clearer, connecting and separating verses.

The vowels in use today are mainly placed outside and below the letters themselves. Vowel marks are not used in Torah scrolls but are found in books of the Bible and in Hebrew literature. They help people who haven't read Hebrew for years, or who are barely familiar with it, pick out sounds and words and keep in touch with tradition.

The letters of the alphabet, when used in combinations, also form numbers (Fig. 1–3). This is not a biblical tradition but an imitation of a Greek custom.

The numerical value of each consonant is the value of the first letter of the name: **A**lef, **B**et, **G**imel, and so on. The letters *alef* through

ע	70	
פ ף	80	
צ	90	
ק	100	
ר	200	
ש	300	
ת	400	

א	1	
ב	2	
ג	3	
ד	4	
ה	5	
ו	6	
ז	7	
ח	8	
ט	9	
י	10	
כ ך	20	
ל	30	
מ ם	40	
נ ן	0	
ס	0	

Figure 1–3

yod stand for the numbers 1 to 10. *Kaf* through *tzadi* stand for 20, 30, 40, 50, 60, 70, 80, and 90. *Kuf* through *tav* represent 100, 200, 300, and 400. Numbers above tens are represented by combinations of letters with the higher numbers placed to the right:

13 =	י+ג	(3 + 10)	500 =	ת״ק	(100 + 400)
47 =	מ+ז	(7 + 40)	900 =	תת״ק	(100 + 400 + 400)

Later, the final forms ך, ם, ן, ף, ץ were used to represent 500, 600, 700, 800, and 900. Thousand units are represented by a kind of apostrophe. However, 15 and 16 are not written as combinations of *hehs*, *yods*, and *vavs* because the letter combinations spell out God's name. God's written name is holy and cannot be destroyed or defiled. Instead, 15 and 16 are written as 9 + 6 and 9 + 7.

THE ART OF CALLIGRAPHY

This book represents three distinct aspects of art—the imaginative, the practical, and the classical. The intent is to bridge the gap between the past and the present, the religious and the secular, the student and the professional. A total picture will be created for the Hebraic calligrapher by explaining the creation of each letter, giving the student a better understanding of the alphabet and its heritage.

Tradition cannot be ignored, but lettering should reflect the times. Calligraphy is not meant to imitate typography but to achieve similar clarity. Calligraphy encourages the personal input of the scribe. Despite the rules, self-expression is boundless. Of course, the rules dominate the mind at first. In time, the rules become second nature to the mind, eye, and hand. Initial attempts at writing will be wobbly and irregular, but practice will overcome this. As the student advances, his or her personal interpretations of the letters will result from a thorough understanding of the basic principles.

Words to the wise! Anybody can learn this art in a few lessons with the help of some explanations and methodical exercises. Avoid discouragement. Don't set limits for yourself by saying "It's too hard" or "I could never do that." Don't become overconfident either. False praise from friends and family gives a false sense of security. You are liable to stagnate if you don't encourage yourself to improve. Hazal gives the *mashal*, a clarification offered by the sages. Take the example of a man climbing a ladder up to heaven. If the man keeps on climbing, he will constantly be striving and achieving in his life; if he reaches a rung that feels comfortable and settles there, he will be passed by others on their way up. In effect, you will backslide, because when you compromise on one point, you are actually compromising on a lot more.

PART II

THE ART OF
HEBREW CALLIGRAPHY

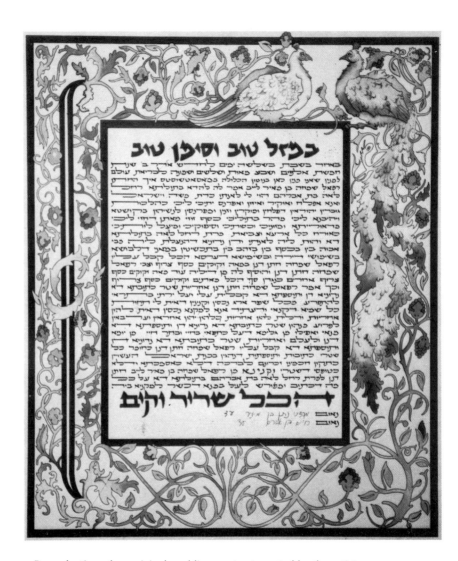

Reproduction of an original wedding contract created by the artist.

CHAPTER 2

SUPPLIES AND
DEMANDS

Calligraphy is unique among crafts because it requires only a minor investment in art materials. With a few inexpensive items—pen, pencils, paper, and ink—you can produce beautiful gifts and works of art. Buy only good materials; cheap materials save money initially but in the long run end up costing more, as they need to be replaced more often and diminish the quality of the final product.

Familiarize yourself with your nearest art supply store. The shelves will be filled with calligraphy supplies. The store's clerk or manager should be knowledgeable of the materials they are selling. They should be able to answer any questions about the use of different supplies and whether or not they suit the project you are working on. Visit your art store frequently to keep abreast of trends and innovations in the art field.

HAZARDS AND SAFETY

A few words of caution. Many of the materials used by artists are potential health hazards. By taking a few precautionary measures, you should have no problems.

Artists are usually unaware of their frequent exposure to toxins

through the mouth and digestive system. This is particularly common among artists whose studios are in their houses or apartments. Toxins enter the body by skin contact, by inhalation, and by oral ingestion. The skin has a natural barrier, a waxy outercoating and a layer of dead cells mixed with a protein called keratin. This barrier can be destroyed by many substances. If they penetrate the body, toxins can travel into the bloodstream and other parts of the system. Care must be taken to make sure chemicals do not come into prolonged contact with the skin, thus destroying the outer barrier.

The most common way that toxins enter the body is through the inhalation of vapors and dust, which damages the linings of the airway and lungs. The finer the particles, the more dangerous they are.

Rules of Safety

1. Ask questions about the materials you are using. Be sure to ask the art store clerk about the potential toxicity of the materials you will be working with.

2. Work in a well-ventilated room to minimize the danger of inhaling toxins from materials such as rubber cement and paint thinner. If you experience any of these symptoms— nausea, dizziness, blurred vision, headaches—check with your doctor. You may be having some kind of allergic reaction to the materials.

3. Make sure your work area is orderly and uncluttered. Not only will this improve the quality of your work, it will also decrease the number of potential accidents, such as cuts from X-acto® knives or paint spills. Wear a smock to protect your clothing.

4. Keep all your materials away from young children, as many of the paints and inks are potential hazards if swallowed. When not in use, keep supplies locked up in a box on a high shelf.

5. Food and drink in the art area increase your risk of contamination. Do not eat while you work.

6. Clean your hands and clothing *thoroughly* after leaving the art area.

7. Remember, the same toxins that can poison a human can poison a pet. Keep your pets away from your supplies!

For more information on health hazards from artists' materials, write to the Foundation for the Community of Artists, 280 Broadway, Suite 412, New York, New York 10007, (212) 227-3770.

MATERIALS

Here is the list of materials you will require for calligraphy. Most materials will be readily available at your local art supply store. If not, you can order them from the store's catalogue.

Light source

Writing surface

Paper: bond; parchment; vellum; tracing paper; writing pad

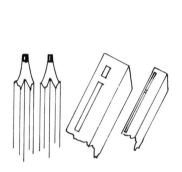

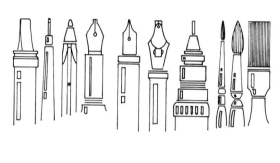

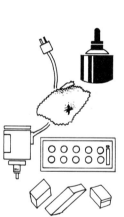

Writing materials: pencils; black felt-tip fine-point pens; graphite sticks; rapidograph technical pens (choice of pen nibs #00, #1, #3); rapidograph pen ink; calligraphy pen with choice of B2, B3, and B4 nibs; pens—dip pens (pens to dip in ink), cartridge pens (which hold ink in cartridges), reservoir pens (which hold ink in the reservoir of the body of the pen), or quills (feather shafts); extra nibs; brushes; inks; paints in cake or tube; ink and pencil erasers

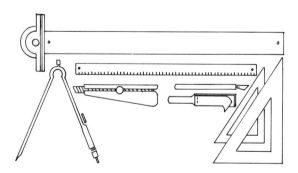

Tools: T square; ruler; triangles; compass; X-acto® blades; sandpaper block

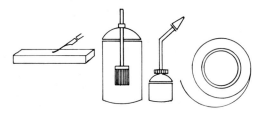

Miscellaneous items: Dennison's® white masking tape; compass with ruling pen attachment; pen wiper; oilstone; masking tape; rubber cement; rubber cement thinner; permo or pro white; paper

Most of these items are essential to the art of calligraphy. But before you rush out to buy everything on the list, let's discuss some of them a little more.

LIGHT SOURCE

Lighting is the most important and often the most neglected factor in doing art work. Some people are more concerned with saving a few pennies by not buying a lamp than with eyestrain. Remember, eyes are a precious and irreplaceable commodity, and must be protected at all cost.

The overhead incandescent bulb in your room is the worst light for doing painstaking, close-up work, which is demanded in calligraphy. Your eyes are forced to work twice as hard when they have to concentrate on small shapes under a hazy light.

The ideal working situation is in the daytime at a desk facing a north window, where natural light can fall on the writing surface. North light is the most even light. The worst light is the yellowish cast of the incandescent bulb. Work done in incandescent light takes on a darker cast than anticipated because incandescent light lacks the clarity of the bluer, clearer fluorescent light. Incandescent light is harder on the eyes, and makes it more difficult to see your work. The cool light of fluorescent bulbs enables you to see the work sharply. Color work done under fluorescent light appears lighter in daylight. There are table fixtures that combine fluorescent and incandescent bulbs in one unit: the fluorescent bulb encircles the incandescent bulb and the light of the two together imitates natural daylight. Whatever light you choose, remember that work begun under one light should be finished under that light because of the different effects of light on color work. It is a good idea to use an artificial light in conjunction with regular daylight: it brings the work into sharper focus, and as the daylight recedes, it helps your eyes adjust to the changes.

The light must be pointed toward your writing hand. Light for the left-handed calligrapher should come from the right, and light for the right-handed calligrapher should come from the left (Fig. 2–1). If the

light comes from behind your hand or over your shoulder, a shadow is cast on the writing area, forcing you to strain to see black letters in a gray patch.

Figure 2–1

WRITING SURFACE

Your choice of drawing board will depend on the seriousness of your interest in Hebrew calligraphy. If you're not sure that you intend to involve yourself seriously in calligraphy and simply wish to give it a try, buy a relatively inexpensive double-weight illustration board. The boards come in 30″ x 40″ sheets, but can be cut to 24″ x 30″ sheets by the art store clerk. Double-weight illustration board is made of two sheets of illustration board laminated together, thus producing a firmer, less flexible surface than single-weight illustration board. Masonite® boards, bought from a lumberyard and cut to 24″ x 30″, will serve the same purpose. They are sturdier and more solid than the double-weight board. These boards are not meant for long-term use—something sturdier will be required if you continue in calligraphy.

Heavy-weight drawing boards made out of pine are very common among artists; these boards are good for use in one place but are cumbersome and inconvenient to carry around, so art suppliers have devised a portable drawing board. Feather-weight boards, called *homosote*, have metal sides and hollow interiors. They are good for use with the T square (pine boards tend to warp, thus affecting the edge against which the T square is aligned). Boards come in a variety of sizes and prices. I recommend the 24″ x 30″ size.

The drafting board is a must for serious calligraphers. It saves time and effort and minimizes errors in layout. The portable drafting board comes equipped with a carrying handle. The back of the board has two friction cups to prevent the board from slipping on the table. Leg props raise the board off the table, increasing the writing angle. The parallel bar operates on a pulley, sliding up and down the back of the board, effortlessly but accurately, saving the calligrapher time in ruling out the guidelines. A newer model has a circular panel in the middle that

rotates, enabling the calligrapher to work on the top or the bottom of a piece without rotating the whole board or lifting the piece from the board. This greatly reduces error in matching horizontal lines.

Drafting tables are invaluable to the artist, particularly for use with a drafting machine. Tables are a major investment and come in a variety of forms. The most common table is the student-grade collapsible table; however, it is not recommended because the base is not completely sturdy and comfortable for the user, and the legs are awkward to adjust. The best moderately priced model is the wood-base drafting table used by commercial artists. The surface board is softwood and the base is hardwood finished in golden oak—both rigid and durable. The height is adjustable from 32 inches to 42 inches. Two semicircular iron arch supports make all board angle adjustments easy. There are other models that use wing nuts and elongated hole rods— they are a little more difficult to adjust. There are many table models available and the serious buyer should investigate all of them.

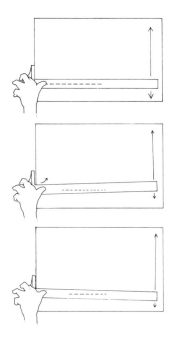

There are a number of sophisticated drafting machines available in quality art and drafting stores. The more professional the machine, the faster and easier it is to turn out good work. Drafting machines can be very sophisticated and expensive, but for serious calligraphers and artists who need to draw many straight lines on the horizontal and the vertical, they are a necessary luxury. They facilitate and expedite drawing lines on the horizontal, vertical, and diagonal. The drafting machine is attached to the upper edge of the table. It operates on a horizontal–vertical axis. The 18-inch plexiglass rulers are rotated to different angles by a pivotal handle. A horizontal track is anchored to the edge of the table. A vertical bar rides freely along the horizontal track. The bottom end of the bar rolls along on a little wheel and the pivotal handle rides up or down vertically on a track on the horizontal bar. The horizontal action of the vertical bar, the vertical action of the handle, and the rotation of the pivotal handle are controlled by a system of locks to prevent slipping and shifting of the guides. The rulers must be adjusted every so often to make sure they are level.

A less expensive version of an "art table" with rule bar and rulers attached to a rotating head is also available in art stores. It retails for approximately fifty dollars. A cheap, plastic, portable version of the drafting machine, it can only be used on pieces that are less than two feet wide. It does not have the accuracy of the expensive drafting machines but will facilitate and expedite lining up your paper.

PAPER

The earliest manuscripts in Europe were written on paper produced from Egyptian papyrus. The earliest surviving Judaica manuscripts, the Dead Sea Scrolls, were written on parchment, which

replaced papyrus during the Middle Ages. Around the thirteenth century, parchment was replaced by paper made of linen: rags are boiled, shredded, and beaten to separate the fibers; the pulp is then run over a fine screen in thin layers, the water is drawn off, and the pulp is dried and pressed into sheets.

Paper is a weblike mass of highly absorbent, intertwined fibers. Impressions are created by drawing a pencil or crayon over the surface of the fibers, wearing them down, and trapping particles from the writing implement in the spaces between the fibers. In order to use paint or ink on paper, the paper must be impregnated with *sizing* (blotting paper is unsized). Sizing is a weak solution of gelatin or hide glue (glue made from animal skins and hides), added while the paper fibers are in pulp form. The amount of sizing is important: too much makes the paper irregular or spotty, too little dulls the paper. Some manufacturers now use chemical sizing, which they claim is superior to gelatin sizing.

The papers are passed through a press. Hot pressed (HP) and cold pressed (CP) papers have open, coarse textures and are used for watercolor paintings. HP papers are suited for opaque techniques and other drawing purposes. The coarseness of the grain has little effect on the paint's adherence to the paper but does add sparkle and zest to the overall appearance of the work.

Quality papers carry a watermark, or embossing, of the manufacturer's trademark. The side on which the mark can be read is the side on which to work. Many papers are well finished on one side, with irregularities and blemishes on the reverse; some papers are finished so they can be used on both sides.

Thickness of paper is measured in pounds or ply. Paper is packaged in 500-sheet reams. If a ream of paper weighs 140 pounds, then a single sheet is 140-pound paper. Seventy-two-pound paper is a very light-weight paper that wrinkles. Ninety-pound paper is an intermediate weight and 140-pound paper is heavy-weight paper. Boardlike sheet, called 250–400-pound paper, withstands severe treatment and manipulation. Ply refers to the number of sheets joined together by the paper mill. One-ply is a very light-weight sheet that buckles under watercolor. Two-ply is made of two sheets joined together and is sturdier than one-ply, and so on to five-ply, which is almost boardlike. A board is more than one sheet of the same paper bound together, or a combination of papers bound together, to produce stronger paper.

The trade names for paper sizes are: Royal, 19″ x 42″; Super Royal, 19¼″ x 27″; Imperial, 22″ x 30″; Elephant, 23″ x 29″; Double Elephant, 26½″ x 40″; and Antiquarian, 31″ x 53″.

The Strathmore Paper Company in Massachusetts manufactures a bond paper beautifully suited to calligraphy and decorative art borders, Strathmore Bristol Bond Kid Finish®. It is the only paper I use for my calligraphic documents. The paper is 100 percent cotton fiber and

comes in 23″ x 29″ and 22″ x 30″ sheets. The 23″ x 29″ sheet, known as Series 505®, is a professional-grade paper, while the 22″ x 30″ paper, Series 405®, is a student-grade paper.

One hundred percent rag paper is a misnomer. It is actually made of 100 percent cotton fibers, which are longer and stronger than linen fibers. There is no acid used in the manufacture of the linen fiber. Because no acid is used in the manufacture of the raw material, a nonyellowing paper with a longer life and a more lasting picture is created. Of course, the paper will yellow if it is exposed to direct sunlight for a long time or if it is improperly matted.

Do not use illustration board for permanent painting because it is made of common pulp wood board. It is acidic in nature, and becomes yellow and brown with age. The discoloration will eventually affect the paper with which it comes in contact.

Light-weight watercolor papers, if not protected, would suffer from the average handling a paper receives. All works on paper should be attached to a heavier backboard. People often mount art on corrugated backing boards, which are very acidic. If they are backed against 100 percent cotton paper, eventually acid will seep into the cotton paper and cause yellowing.

When artworks are completed, they should be matted to prevent the paper edges from becoming soiled, bent, or creased. They should also be backed and the front covered with acetate. The acetate cover sheet protects the work from dust and water damage. The transparency of the acetate allows the picture to be protected but still seen.

I had the occasion to witness a beautiful calligraphic piece, exhibited at an outdoor show, destroyed in a light rain. The artist had used nonwaterproof ink to write with and had not covered the work with protective acetate. The rain caused the ink to bleed rivers down the page, destroying the work completely.

Work done on quality paper is distinguishable from work done on cheap, inferior paper. Inferior paper inhibits the artist from properly using pens, pencils, and brushes, and prevents the artist from producing superior professional effects.

At times, calligraphers get special orders for work on parchment or vellum. *Parchment* is made from sheepskin. Some calligraphers prefer it to vellum, though it is coarser to the touch. Parchment has a smooth white side (the flesh side) and a rougher yellow side (the hair side). The smooth side is preferable to write on, but it can easily be damaged, so care must be taken in handling it. All erasing must be done gently with an India ink rubber. It is best to be careful and avoid mistakes altogether. The finest grades of parchment are made from the skin of a newborn animal. The skin is soaked in water to become soft and pliable. Then it is stretched, dried, and subjected to a number of finishing and surfacing operations to make a good permanent work surface.

Vellum is the name given to good calfskin prepared for writing. It is sensitive to weather conditions, curls up in hot air, and wrinkles and stretches in damp weather. Modern skins tend to be too stiff and horny, a result of impatience in preparing the vellum: the chemical treatment and careless sizing and dressing. Vellum does not take well to watercolors.

The art of preparing vellum is acquired through practice and experience. There are four basic steps:

1. Place the vellum on a padded surface made of papers stacked together. If you are going to use newspaper for the padding, separate it from the vellum with a plain white sheet of paper so the newsprint won't transfer to the vellum.

2. Rub the hair side well with finely powdered pumice to create a nap for the nib to write on. (If the vellum surface seems greasy, wrap some fine glass paper [similar to sandpaper] around a wooden block to roughen the skin, in preparation for the nib.)

3. Rub *sandarac* (a resin rubbed on erasures to prevent ink from spreading when the surface is written over) lightly on the flesh side; dust it lightly on the hair side. This will stop the ink from bleeding over the skin. Apply the sandarac gradually, adding more as needed. Too much makes the surface difficult to work on and leaves scratchy spots where the ink will not flow well.

4. When done, shake the excess pumice powder and sandarac from the skin.

Mistakes on vellum can be corrected with a sharp knife, eraser, or pumice powder. To avoid producing a gray smudge on the skin with an India ink eraser, scrape the surface lightly with a blade at right angles to the vellum. Scratch away the ink a bit at a time, taking care not to cut into the paper with the knife. When done, burnish to smooth the roughened surface.

Artificial parchment, also called vegetable parchment, comes in snowflake (white) and antique (yellow brown). It is not 100 percent cotton paper, and is not meant for permanent works.

Test paper surfaces on the sample cards provided in the art store. Try thin strokes ☰ and thick strokes ☰ . On slick paper, the ink tends to bead up, the lines tend to be too thick, and the pen moves too fast. Ink lines on rough paper have ragged edges. There should be enough friction between the pen and paper to assure legible letters. Too much friction will slow the pen down.

Tracing paper is essential: all preliminary design work is done on the tracing paper. This way, every line can be thought out and adjusted without damaging the surface of the final writing paper. Elements can be corrected and moved around until a suitable layout is devised. The design is later transferred to the final paper. Tracing paper is transparent, and comes in different opacities and weights—middle-weight paper is best—and in either pads and rolls. Rolls are economical in the long run and are convenient for large pieces. Tracing paper is used for thinking out the design, and also as a spot to rest the arm of the writing hand, thus keeping the final sheet free of sweat marks, stains, or smudges.

I am often asked why designs cannot be drawn directly on the final sheet. When a pencil is drawn across paper, it leaves a crease, or gully, in the paper surface. Erasing removes the graphite, but not the gully. Subsequent lines drawn across the paper are affected by the mark in the surface. To avoid swivels and shaky lines, use tracing paper before transferring the design to the final drawing paper.

A *writing pad* should be used under the writing paper. Paper on a wood surface tends to slide and the pad creates friction by holding the paper in place. It also decreases the tension caused by writing on a hard wood surface, which strains the writing hand and wears down the pen nib. The pad can be made of several blotter papers, laid one on top of the other (blotter paper comes in 24″ x 38″ sheets and can be cut down accordingly). The pad should be larger than the writing paper on all four sides; if it is smaller, the final paper will be creased on the edge. Quality art stores carry a commercial nonskid vinyl pad called Vyko® (manufactured by the Alvin Company) that is ideally suited for the purpose.

WRITING MATERIALS

Pencils come in varying degrees of hardness, ranging from 7B, the softest, to 9H, the hardest. HB is a medium-grade pencil. The lines of H pencils do not smudge easily. For drawing letters and guidelines, 3H is best; 4H and 5H are best for ruling lines; 7H is best for transferring lines. To produce soft black lines that are good for sketches and roughs, use 4B and 5B pencils. Thick-leaded carpenters' pencils, cut to a chisel point, are sometimes used for practice writing, as are double-edged pencils.

Graphite sticks are used for wide lettering. They are marked H to B, like the pencils. Sticks numbered 4B and 5B are used to create a carbon-like paper for transferring designs from tracing paper to the final writing paper.

To make carbon-like paper, rub the broad side of a graphite stick

back and forth across the paper until it is completely blackened. The graphite covered sheet is slipped, graphite side down, between the two papers. After the inking is completed, gently erase the graphite guide lines with a kneaded or Eberhard® eraser.

Double-edged pencils are excellent to practice with before handling an edged pen. They assist the beginning calligrapher in studying the construction and form of an alphabet's letters before writing with a nib.

To make double-edged pencils you need two sharpened HB pencils, a sharp knife, two rubber bands, an X-acto with sharp blades, and a sandpaper block. The following instructions are for right-handers. Left-handers should reverse the directions.

To sharpen pencils, grip the pencil in the left hand with the point of the pencil facing toward you (at about midriff height). Hold the X-acto gun (the gun-shaped handle) in your right thumb against the pencil to stabilize it. Slowly pull the X-acto toward you, shaving the pencil in a downward stroke, all the way to the pencil point. Repeat this all around the end until a sufficient carbon point has been exposed (see Fig. 2–2). Rub the pencil carbon back and forth on a sandpaper block on all sides to make a sharp point, pausing every so often to blow off the excess carbon that has collected. You can give the pencil any type of point you want, from a sharp point to a dull point to a chisel point. This is the only way to sharpen a pencil for art purposes.

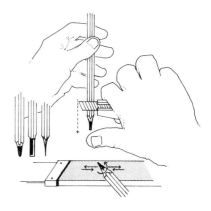

Figure 2–2

The two pencil points of a double-edged pencil must be level to give an even writing edge. A rightie may raise the left pencil higher. A leftie may raise the right pencil higher (Fig. 2–3). Hold the pencils comfortably while writing. A tight grip produces stiff letters and a cramped, tired writing hand.

Double-edged pencils represent a pen's edge. They give the effect of thick and thin strokes achieved with a nib. Double-edged pencils help the artist visually break a stroke down into its basic form, making it easier to analyze the letter's shape from an outline drawing. The bare form clearly shows how strokes unite with each other, intersecting or meeting at certain points. This is not as obvious when studying the letter forms made with a pen. The beginning letterer will discover that there is a tendency to press more on one point than another, instead of drawing freely and easily to produce equal lines.

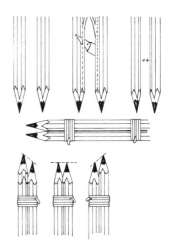

There are a variety of *pens* available on the market. The important thing to look for in a pen is a good round barrel that fits comfortably into the hand. The easiest pen to use, for professional and beginner alike, is the Osmiroid® fountain pen. The Osmiroid 65 is of average thickness with a side filling lever. The Osmiroid 75 has a slimmer barrel and is filled by means of a plunger mechanism at the top. Both pens use the Osmiroid nibs interchangeably.

Figure 2–3

There are a number of other types of pens used by calligraphers.

Figure 2–4

Figure 2–5

Figure 2–6

Figure 2–7

Bamboo pens give uniform and free-flowing lines. They work well on rough watercolor paper, giving a dry-brush effect. The *stylus* is a reservoir pen with a cylindrical pipelike point. It is used primarily in mechanical drawing. The *ruling pen* is used for inking mechanically straight lines with a ruler, or curved lines with a french curve. The ruling pen contains a brush loaded with ink (Fig. 2–4). The size of the line varies according to the width that the point is opened. *Technical pens* are used for drawing single-thickness lines, art work, and decorating letters with continuous lines. *Quills* are the traditional tool of the scribe (Fig. 2–5). They are hard to locate and hard to make; courses in the art of cutting and using quills are available through the Society of Scribes.[1] Braun manufactures a plastic quill that can be purchased in better art stores. It is not as good as the genuine article though.

The best *nibs* (removable pen tips) for Hebrew calligraphy are the Osmiroid B2, B3, or B4 nibs. Broad nibs are responsible for the thick and thin strokes in lettering that are created by slightly varying the pressure applied to the pen. Speedball® nibs are used primarily for lettering and come in round, oval, square, and chisel-edged points. The round nib produces lines of uniform weight. The oval nibs produce a slight difference in weight of the line (i.e., the line can be made thicker or thinner in places). The flat and square nibs are used to achieve noticeable thicks and thins. Each nib has a small ink reservoir that is filled up with a brush loaded with ink (Fig. 2–6). *Chronicle nibs* have both stiff and flexible points for fine and thick lines. They are good for drawing, fine lettering, and work needing the utmost flexibility and fineness.

Osmiroid and Platignum® pens can be used with waterproof ink, though this might cause the pen to deteriorate more quickly than if non-waterproof ink is used. The cost of a pen, however, is negligible in contrast to the hours lost on a beautiful work of art that is destroyed in seconds by a spill that causes the letters to bleed. I have used the same pen with waterproof ink for over nine years and have not had any problems with pen deterioration.

The Mitchell Company sells cards bearing an assortment of nibs. They are reasonably priced, and while the nibs are all interchangeable with the proper pen bodies, it is cheaper to buy the one nib you need rather than a whole card of nibs you don't need.

Wash and dry nibs carefully after each use or they will rust. To sharpen metal nibs (see Fig. 2–7), hold them reverse side up and at a slight angle to an oil lubricated oilstone, gently drawing them across the stone. Be careful not to sharpen too finely, as the tip will cut the paper surface.

[1]See also Edward Johnston's *Writing and Illuminating and Lettering*, Chicago: Pitman Publishing Company, 1945.

There are many types of *brushes*, each with its own purpose. The handles of different brushes are shaped to suit the purpose for which they are intended, with a certain length and proper balance. For example, watercolor brushes have short handles. The widest point of the hair, the *belly*, is gripped by the metal *ferrule*, which connects the hairs to the handle of the brush. The tips or points of brushes are natural, uncut ends of animal hair. The longer the brush hairs, the more expensive the brush. Cheap brushes are not that economical: they need to be replaced more often, the glue loosens easily and hairs fall out, the hairs spread in midstroke, and have little body.

The quality of a brush is determined by the resiliency of its hair and the sharpness of its point. *To choose a brush*, follow these simple steps: dampen the thumb and forefinger with saliva or water, pull the brush loosely through the thumb and forefinger, and draw the hairs to a point. Reject a brush whose hairs do not come to a point; it will lose its shape and produce a ragged painting line. Another test is to press the tip of the hairs down after they have been dampened. When released, they should spring back up, parallel to the handle (see Fig. 2–8). If the point stays down, the quality of the paint line will be affected.

Figure 2–8

The finest brushes are made from Siberian mink. They offer springiness and durability; the hairs are delicately tapered to a fine point. Flat sable brushes are used for uniform letters and sometimes brush scripts. Pointed sables are used for thick and thin lettering. The smaller size sables can be used for whiting out, correcting finished lettering, and painting small areas with color. Red sable brushes are the best brushes for regular painting. Windsor Newton Series 7® red sable brushes are the Cadillac of paint brushes. Every artist should have a variety of the smaller brushes, #00, #1, #3, and a couple of the larger brushes, #15 or #8.

To preserve brushes, rinse them immediately after use with the appropriate solvent, paying particular care to the pigment collected in the belly and the heel of the brush. Shake or wipe off excess solvent. Wash well with lukewarm water and mild soap. Do not use hot water, which will loosen the glue holding the hairs and cause them to fall out. To maintain the brush's shape, draw it lightly across the soap bar, bringing the hairs to a fine point; leave the soap on until its next use, and then rinse the brush well before you use it. Do not leave brushes standing on their hairs in water. They should be stored flat in a closed box or drawer with mothballs because moths are attracted to sable hairs.

Liquid *India ink* has almost replaced India ink in stick form. Waterproof ink is usually a solution of shellac and borax. It withstands the effects of water after it has dried, and produces a jet black line; the starkness of the black line against the white paper tests the quality of your writing and shows up faults. Soluble ink produces a line varying

in black and gray tones that can be washed away when it is gone over with water; if dribbled with water it will bleed rivers of ink down the page. Both waterproof and soluble inks can be diluted with water while they are in the liquid state. India ink will clog a pen unless the nib is wiped frequently with a rag. If the pen is severely clogged, fill it with fresh ink or soak the nib in water. I use Pelikan Waterproof Black Ink® (the bottle with the yellow label), which gives a jet black line that will not run. Other soluble inks can be used for practice sessions, although it is best to practice with the materials you will be using in the final piece.

Colored inks are made to meet every writing requirement except permanence. They were designed for commercial use and should not be used for permanent paintings. They are called "fugitive colors," as they begin to fade the minute they are committed to paper, generally lasting from three to five years. Colored inks conceal faults in the written letter and give a false appearance of excellence.

Writing inks are a combination of tannic, gallic, and dilute hydrochloric acids with iron, salt, phenol, and black or blue dye. The best writing inks flow well, have the least corrosive action on pens and paper, and give the most permanent results. The ink will fade when continually exposed to sunlight, as will the *liquid dyes* used in nylon and felt-tip pens. Some marker lines spread quickly on paper, making it difficult to achieve a fine line. They contain reservoirs for free-flowing inks that dry instantly. Markers were designed for commercial use—not for the artist. They are only good for making initial sketches or going over pencil lines on tracing paper. The colors in markers are soluble dyes and neither permanent nor lightproof. Those sold as permanent colors are actually only temporary. The fading of colors exposed to sunlight is an irreversible chemical reaction in which the pigment changes to a colorless compound. Be careful to choose materials designed for artists' rather than industrial use.

As for *colored pencils*, the brighter colors are produced to suit industrial needs for brilliance rather than the artist's need for permanence. Pencils labeled "peacock blue," "grass green," and "golden yellow" should not be used; standard names like "burnt umber" and "cadmium red" can be trusted. As a general rule, avoid colors in which the pigment compounds are not identified.

Watercolor paints in tubes and cakes are inexpensive and easy to use (try Pelikan® and Marabu®). They are made of transparent pigments ground to an extremely fine texture in an aqueous solution of gum. They can be diluted and combined with other pigments and will still stick to the paper. When applied thickly, the pigments have a tendency to crack if the paper and/or its backing are not rigid. When permanent watercolors are used on good watercolor paper and kept under normal conditions, the result will endure.

Polymer colors are made by dispersing pigment in an acrylic

emulsion. The colors can then be diluted with water. When dry, the resin forms a tough film, resistant to water. Polymers are nontoxic and can be made matte, semi-matte, or glossy by mixing them with the appropriate media. *Acrylic colors* share the same properties as polymers. However, there is some question as to the longevity of a coating that contains a drying oil and acrylic resin, which is used in acrylic paints. *White paint* such as Permo White® or Pro White® is used for touching up and correcting lettering or for lettering in white on a dark background. The corrections should only be done on pieces used for reproduction, if at all. Touch-up paint should not be used as a crutch. The artist should strive for a perfectly written text.

Kneaded and pencil *erasers* are used to remove unwanted pencil guidelines. The kneaded eraser is cleaned by pulling and stretching it like taffy. Ink erasers are abrasive, used to remove unnecessary ink lines and mistakes without destroying the texture of the paper. Four- or five-ply papers are excellent to use because mistakes can be easily corrected without damaging the paper. Erase with a circular motion, being careful to erase only when the ink is dry. Vigorous rubbing will produce a hole in the paper, so be careful. A little gum sandarac rubbed over the erased area will prevent the ink from spreading on the lightly roughened surface. Battery-operated and electric erasers can save on the wear and tear of the hand. An electric eraser is expensive. It is excellent for large patches, but it does have one drawback—it isn't really abrasive enough to do a quick job, so erasing takes a little longer than it should. The battery-operated eraser needs constant recharging, but it is considerably less expensive than the electric eraser, and weighs less.

TOOLS

The *T square* is used for drawing parallel horizontal lines. It consists of a short bar intersected at a 90° angle by a long bar that should measure no fewer than 24 inches. Buy a T square with a flexible steel shaft thin enough so that a rapidograph drawn alongside it can easily touch the paper. A steel shaft is important for use as a guide for an X-acto knife. Try to get a T square with a beveled edge on the underside. The bevel keeps the pen away from the metal edge, preventing the ink from being drawn underneath and blotting the paper. Aluminum T squares are inexpensive, but they are also clumsy to work with because they are thick and inflexible. Aluminum can be nicked by a cutting blade, damaging the surface along which the pen or pencil is drawn. Wooden T squares cost even less and are poorly constructed and easily cut with a blade. Be forewarned that the wooden T square joint can be loosened, affecting the accuracy of the drawing line.

Figure 2–9

Figure 2–10

Figure 2–11

The T square is used by setting the short end flush against the edge of the board. It is then anchored firmly in place by holding the middle finger against the center of the T square head, while extending the thumb of the same hand out onto the rule. The thumb will hold down the T square bar firmly on the paper, preventing it from shifting. If the middle finger is not centered on the head, the line can easily shift up and down. If this happens throughout the whole piece, you will end up with a sloppy piece of work.

Buy a steel *ruler* about 18″ to 24″ long, scaled in inches and centimeters. Make sure it has a cork bottom to raise the metal edge off the paper; this eliminates the possibility of ink being drawn under the metal edge and ruining the page. Keep the ruler clean of marks or stains that will damage the final writing paper (Fig. 2–9).

Triangles are needed to draw vertical guidelines (Fig. 2–10). There are many choices of angles available, but for purposes of calligraphy, a right angle triangle should be used, as it provides a 90° angle to the horizontal line of the T square. Some triangles come with a beveled edge. These are the best to use, because they keep the ink and ruler lines from meeting. Triangles are available in solid metal, opaque and transparent plastic, and wood. Clear plastic triangles are best, as they allow the writer to see through to the writing page. However, they also tend to scratch easily and collect dirt, so make sure your triangle is free from ink or other marks that might blemish the writing page. They can be cleaned with rubbing alcohol on a tissue. The triangle is moved smoothly along the long bar of the T square when the bar is set firmly against the drawing board.

A *compass* is necessary for circular designs. The most commonly used compass has two arms, one with a point and the other for a pencil or pen attachment. There is a compass on the market designed to hold technical pens. It also has a pencil arm. The compass should have a minimum span of 12 inches in the diameter. Some models have bar attachments that dramatically extend the reach of the compass.

Compass points should never be stuck directly into the working surface. To prevent piercing the paper, wad up a very thick masking-tape ball into an oval shape. Cross at least two pieces of masking tape over the wad to anchor the tape to the paper. The compass point can then be placed on the tape, thus keeping it from irreparably damaging the paper (Fig. 2–11).

X-acto blades are used for cutting paper and shaving pencils. They fit into different handles. One type of handle looks like a silver metal pen. By unscrewing the head you can tighten or remove and replace dull blades. There is also a gun-shaped blade holder, which is the heaviest and sturdiest, as well as the most comfortable to hold in the palm of the hand. The refills for this holder come in bars of connected blades. The worn blade is broken off when it begins tearing the paper

rather than making clean cuts. The new blade is shifted down and locked into place.

Single-edged blades can also be used. Be sure to store the blades in a sealed container so they cannot float around the room and be picked up by a child, stepped on, or bumped into.

When cutting with an X-acto blade, be sure it is sharp. A dull blade will tear the paper and leave a ragged edge. Be sure to place your ruler to the inside/art side of the blade. This is protection against an unsteady hand, which can accidentally travel across the paper and cut into the art. Hold your guiding ruler and blade very steady. Cut slowly and carefully. Do not try to cut all the way through right away. Cut lightly the first time to mark your cut. Cut slightly deeper the second time and cut all the way through on the third pass.

MISCELLANEOUS ITEMS

A linen *pen wiper* is needed to wipe the excess ink off of pen nibs to keep the nibs clean. An old hankie will do, but tissues and paper towels are not suitable because they leave a residue on the nib that clogs the pen, causing it to smudge. An *oilstone* is used to sharpen metal nibs.

Masking tape is used to hold the paper or the tracing paper to the board. Tape widths vary. The two most convenient widths to use are ¼″ and ½″. I strongly recommend the use of Dennison's® white gummed tape, which does not tear or discolor the paper as yellow masking tape does. There is a new white tape on the market that has a tackier back to it.

Yellow masking tape is backed with an unstable adhesive that will discolor the surface it touches in a relatively short time. When it is used even for a short while, it is difficult to remove it without tearing the paper. It leaves a tacky residue behind that is hard to get off. Often the discoloration from the tape spreads beyond the taped area. The tape eventually becomes brittle and loses its adhesive powers.

Rubber cement is really only suitable for work done for reproduction. It should never be used for works of permanence, because eventually it turns brittle, darkens with age, permeates the paper, and causes a lot of damage. There is no guarantee that it will not affect the illustration board. Rubber cement is applied with a paint brush. Rubber cement dispensers, bottles with a brush attached to the inside of the cap, are available in art stores.

Benzol, or *thinner*, is used to separate two or more pieces of paper held together with rubber cement. Dried rubber cement becomes less soluble and more resistant with age. A fine abrasive (6/0 garnet paper or a 3/0 steel wool) combined with benzol can be used to remove the

rubber cement. Rubber cement can also be used effectively as a resistant in watercolor painting where the artist wants white left. The rubber cement must be removed soon after the paint is dry. Thinner dispensers, containers with long cone-shaped noses through which the thinner is squeezed and directed, can be purchased in art stores. Use only in a well-ventilated room and not if you are pregnant.

GUIDE SHEETS

Ruled guide sheets are useful and necessary for practicing calligraphy.

Commercial guide sheets are suitable for English calligraphy, but the diagonal lines for italic calligraphy only confuse the Hebraic calligrapher. Often, beginning calligraphers will try graph paper as an alternative, but it doesn't work well. Graph paper is designed for ballpoint pens and pencils, not for markers and calligraphy pens. Markers and calligraphy pens tend to bleed on graph paper because fibers in graph paper are loosely pressed together. Often the paper fibers will lift from the paper, catch themselves in the nib, and clog the pen. *Bleeding* is the term used to describe an ink line that does not stay within the bounds set by the breadth or width of the nib. Instead, little fuzzy streams of ink spread out from the ink line.

The best solution is to make your own guide sheets, several sheets at a time. Don't make the mistake of using poor quality paper, as your hand will have to be retrained when you use better quality paper. Therefore, use good bond from the beginning—four-ply Strathmore Bristol Bond Kid Finish.

Sheets that are to be used for practice can be ruled with a nonreproduceable blue pen sold in commercial art stores. It makes a light blue line similar to the lines on graph paper, and does not interfere visually with the letters that are being written. Ball-point pens are too dark, red pens are too bright. A technical pen with a #00 or even a #1 line can be filled with a light blue technical ink and used to rule the practice lines. Final pieces must be ruled with a 4H to 5H pencil.

Ruling paper for a medium Osmiroid nib. On the left side of the page, approximately 1 ½ inches from the edge, in a column parallel to the edge of the page, mark off a space of ³⁄₃₂ of an inch for the letters and ⁴⁄₃₂ of an inch for the interstices. If a greater space is desired between letters, the space can be adjusted to ⁵⁄₃₂ of an inch but not more than that for straight writing passages.

To review, place the ruler with the centimeter edge pointing in toward the page and the outer edge parallel to the edge of the page. (See Fig. 2–12.) With a very sharp pencil mark off your first millimeter line. It should not be closer than 2 inches to the bottom of the page, leaving a sufficient margin for handling. Count off ³⁄₃₂ of an inch or four

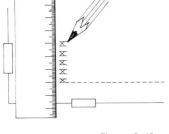

Figure 2–12

lines and mark the fourth line with a pencil mark; count ⁴⁄₃₂ (⅛) of an inch or five lines and mark the fifth line with a pencil mark. Repeat this until all the required lines are marked (Fig. 2–13). To remember which are writing lines and which are spaces, put a small × in between the top and bottom lines marking the ³⁄₃₂ inch lines; thus all spaces for writing will be marked and all spaces between letters will be left empty.

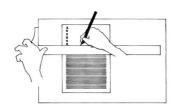

Figure 2–13

On all four sides attach the paper securely to the drawing board with masking tape. Make sure the paper is parallel to the edge of the drawing board and that there is a minimum of 1 inch between the edge of the paper and edge of the board. When inking practice lines use the T square to guide the horizontal lines and the right-angle triangle to draw the vertical guidelines (see Fig. 2–14). Care must be taken that the T square or ruler doesn't touch the tip that feeds the ink. If this does happen, the ink will bleed under the straight edge. To avoid this problem, use a cork-bottomed ruler. A trick of the trade is to create your own "cork-bottomed ruler" by taking your steel ruler and placing a strip or two of masking tape on the bottom side of the straight edge, about ⅛ inch away from the ruler's edge. This lifts the ruler from the paper and performs the same function as the cork. Another trick is to tape three pennies or dimes to the bottom of the ruler, one at either end and one in the middle. The same tricks can be applied to triangles. (See Fig. 2–15.)

Figure 2–14

Figure 2–15

PREPARING THE MATERIALS

Now that you have a number of guide sheets, you are ready to practice calligraphy.

Sit comfortably at a table in a well-lit room. Anchor the ink bottle firmly in place with a cardboard collar and thumbtacks, as illustrated (Fig. 2–16). Keep the bottle top tightly closed between fillings to avoid spills.

Figure 2–16

To make a collar, cut a rectangular piece of cardboard, approximately 2½″ x 7″. Score the cardboard ½ inch from each end. Turn the board over and score in the middle, approximately 1¾″ from each end. (The actual height of the bottle from the tabletop to the cap bottom will vary from bottle to bottle, and must be taken into account.) Cut out a circle ½″ larger than the diameter of the bottle cap from the exact middle of the cardboard. (This will slip over the bottle cap). Fold the middle scores down and the bottom scores up toward the top. Fit the collar over the bottle top. Tack the feet onto the table.

Set the drawing board at a fairly steep slant, 45° to 60°. The board can rest on the edge of the table and into the lap. It can be hinged to the table, with the upper end resting on an object placed behind it (see Fig. 2–17). Bevel or round the edge of the drawing board by sanding it, so that if you are writing on a long sheet of paper and the tail of the

Figure 2–17

paper hangs over the edge of the board, it will not get creased.

Cushion the writing surface with two or three sheets of paper, and anchor these on the board with at least four tabs of white masking tape. Rub the tape firmly down so the sheets won't slide. Draw your fingernail against the tape where it meets the paper edge, making the paper tight. If using Vyko®, anchor it along the edge with tacks. Depress the heads so they do not protrude and rip the writing paper.

Preparing the Writing Paper

Secure the writing paper to the paper, cushioning the board with white masking tape or with a wide elastic stretched across the board. (See Fig. 2–18.) The cushion should exceed the writing paper by at least 1 inch on all sides. Cut a rectangular paper guard from clean scrap paper; it should measure half the length of the writing paper and at least 2 inches wider on each side. The paper guard sits below the writing level, leaving room enough for the hand to write freely. The writing arm rests on the paper guard. It keeps the final sheet clean from smudged pencil lines, sweaty palms, and sundry other accidents. The writing level must be kept constant. Move the writing paper up as lines are written. Do not move the paper guard down, as this would force you into a cramped position, encouraging poorly formed letters.

Keep a piece of scrap paper at the upper right-hand side of the writing paper to test ink-filled nibs before starting to work. Practice a few letters, words, or even lines of writing before starting to work on the final piece. Practice limbers the fingers and gets the hand ready for passages of writing. Clean the paper of dust, erasure residue, or any particles that might catch on the nib and clog the pen (brushes for this purpose are sold in art supply stores).

Clear your work area of superfluous materials. The easiest way to keep your work area neat is to have a place for everything. Commercial catchalls are sold in art stores. They have compartments to hold your art materials, and can be attached to the side of your table. Inexpensive alternatives are shoeboxes or ice cube trays.

Figure 2–18

THE FIRST STROKES

It is essential to know how to hold and control the edged pen before learning how to write with it. Hold the pen above the nib between the thumb and forefinger, resting the barrel on the middle finger. The pen should rest on the paper at an angle of 45° to the writing line. Do not grip the pen tightly. It should be able to slip easily from between the fingers. The whole hand moves the pen in an action from the wrist, not just the thumb and the forefinger. The pen, if held correctly, almost writes automatically. If you hold the pen incorrectly, there is nothing you can do to make it write well. Other hand grips are

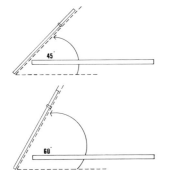

illustrated in the diagrams (Fig. 2–19). The grip between the first and second fingers is very relaxed, exerting almost no pressure on the fingers. The left-handed writer's hand crosses the paper at a 45° angle, with the elbow out, the hand turned comfortably on its left side. Lefties should use a pen cut sharply oblique to the right.

Fill your pen—not too full as too much ink will flood it, and too little will produce scratchy and ragged strokes. Start the ink flowing by scratching the pen sideways on your scrap paper. If you are using a dip pen that has been packed in oil to preserve it, dip it in the ink a few times, wiping it each time until the ink forms a thin, even film on the surface. Set the pen firmly on the paper so its entire edge comes in contact with the paper surface, producing a line with even sides (Fig. 2–20). If the nib leans to the left, the right edge of the stroke will be ragged, and vice versa. Don't press down to spread the stroke—this will damage the nib (Fig. 2–21). With time and practice you will develop a rhythm in your writing. (See Fig. 2–22.)

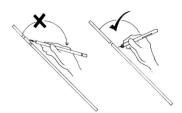

Figure 2–19

Figure 2–20

Figure 2–21

Figure 2–22

Your writing hand must adjust to the raised position. It will tire easily at first, but you'll become accustomed to the position after a while. You must hold the pen in a horizontal position, to keep the ink flowing under control. Do not tense your hand or wrist. Give your hand frequent rests. Shake it. In time, the position will be second nature.

Glide in and out of the strokes of curves. Lift the pen to the side rather than straight up when finishing straight strokes. Don't whip the stroke, move deliberately. Take care to achieve clarity between the down and up strokes (Fig. 2–23). Hold your pen at the proper 45° angle to ensure proper distribution of thick and thin strokes (Fig. 2–24).

Figure 2–23

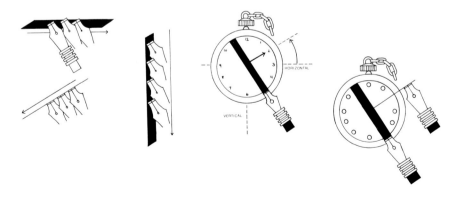

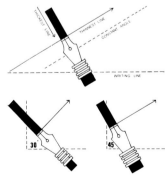

Figure 2–24

Vertical strokes should be square-ended. All horizontal strokes are dense in color. All strokes sloping down from right to left, done with the pen edge, are light.

All strokes sloping down from left to right, drawn with the full breadth of the nib, are strong bands of color. Downward strokes drawn with the full breadth of the nib are heavy. Downward strokes drawn with the side edge of the nib are light. The swell of an accent on a curved stroke is heavy on the sides, light across the top and bottom.

Both light and heavy strokes are written with the whole width of the pen, never with just one edge of the pen. The pen must move closely over the paper.

Curves must be written clearly. They are separated from the annexed stroke by a thin line unless a direct connection is demanded by the structure of the character.

The broad nib is perfect for Hebrew calligraphy (see Figs. 2–25 and 2–26). The chisel edge of the nib gives clean thick and thin strokes and graduated curved strokes, running from a taper to the full width stroke of the nib.

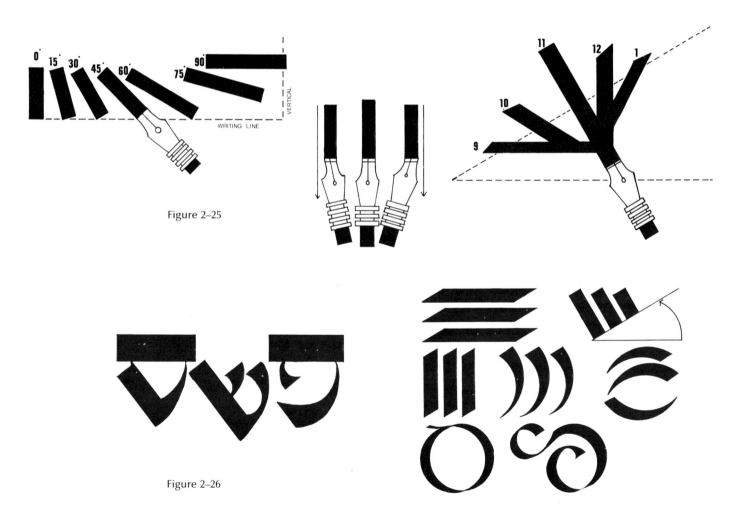

Figure 2–25

Figure 2–26

EXERCISES TO RELIEVE FATIGUE

Sitting in a chair in the same position for a long time is hard on your back. Raise your knees a few inches higher than your hips, taking the weight off your lower spine. Rest your feet on a stool, a pile of books, or a desk drawer pulled out and placed upside down on the floor. Pull in your abdominal muscles and tilt your pelvis back a little by pushing your ribs down toward your stomach. Support your lower back with a pillow at the bottom of your spine.

The sitting pelvic tilt is an excellent exercise to relieve tension. Sit in a straight-backed chair. Both feet must lie flat on the floor. Tighten your stomach muscles, squeeze your buttocks together, and flatten the small of your back into the chair. Hold the position for a few seconds. Begin by repeating the exercise ten times and build up to more.

For the low back stretch, lower your chin to your chest, spread your knees, and let your arms rest between your legs. Roll down slowly, beginning with your head, until your arms touch the floor. The last part of your body to drop should be your shoulders. Roll smoothly without bouncing. Return to the original position by tightening your abdominal muscles, squeezing your buttocks, and rolling up from the base of your spine. Breathe out when going down; breathe in when coming up.

A variation of the low back stretch is the side stretch. Sitting upright in your chair with your feet spread apart, rest both arms to one side of your legs. Roll down and up as indicated in the low back stretch. Repeat on the other side.

Two simple tension relievers are the shoulder shrug and the shoulder roll. For the shoulder shrug, raise your shoulders as high as you can, breathing in deeply through your nose. Then lower your shoulders all the way, breathing out through your mouth. Repeat several times. For the shoulder roll, raise your shoulders simultaneously to your ears and roll them forward, down, and back again to the starting position. Repeat three or four times. Roll your shoulders backwards following the same instructions as those for the forward shoulder roll. Repeat several times. Give your head and hands a quick shake and you're ready to start again.

Firm Grip

Top view

Front view

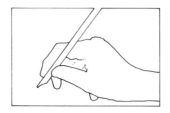

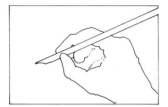

Alternative Method of Holding the Pen

The pen sits between the index and the third fingers and rests at their joint, thus alleviating the pressure usually felt on the fingertips when working too long or gripping too hard. The pressure is evenly distributed between the two fingers, a comfortable position for long periods of writing.

HOW TO HOLD THE PEN

Position for Writing Hebrew Square Script

These are natural writing positions, allowing for relaxed muscle movement and a loose action of fingers.

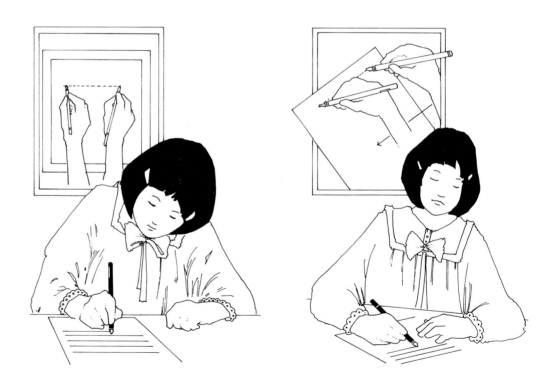

Natural Grip

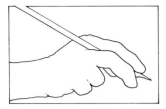

Frontal view Side view Top view

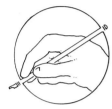

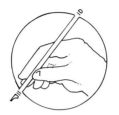

Natural Grip (relaxed, informal) Constricted Grip (formal)

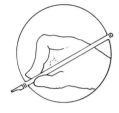

Broken Grip (clenched, too tight)

CHAPTER 3

WRITING THE HEBREW ALPHABET

Hebrew is read from right to left. Words are written in a right-to-left direction but individual letters are written from left to right. Left-handed calligraphers can write Hebrew letters with ease. Right-handed scribes make individual strokes from left to right and then move left, over and past the wet stroke, to start another stroke. Left-handers move right to left, with their hand moving in front of the wet stroke.

THE SKELETON ALPHABET

The Hebrew letter is divided into top, middle, and bottom strokes, with the emphasis on the horizontal strokes. The strong upper horizontal can be lengthened in certain letters (*dalet* ד , *heh* ה , *kuf* ק , *resh* ר , *tav* ת), making it easier to have equal left and right margins. It cannot be shortened: condensing certain horizontals invariably changes the letter, and inevitably, the meaning of the word. Extending characters, a tradition in Hebrew writing, enhances the look of the text. Words cannot be broken at the end of a line or by art. Breaking a word into syllables can create two new words and change the meaning of the text. More of the page shows through when letters are extended. Care must be taken not to place too many extenders in

one spot on the page. Instead, plan ahead to place them artfully on a page.

The *skeleton alphabet* is the "bare bones" drawing of the letters. It helps students understand the shapes without the visual complication of the decorated form, and is the key to understanding the proportions, form, and basic characteristics of each letter. Draw skeleton letters with a soft pencil. Don't write too small, or you won't be able to see the faults and irregularities in your letters. Draw the letters freely, without hesitation, and avoid mechanical-looking writing.

Now let us go through the alphabet, one letter at a time.

The diagonal of the *alef* runs corner to corner in an imaginary square. It shouldn't be too sharp or too soft. The left foot attaches to the left shoulder by a straight or slightly angled descender. The right hand starts about two-thirds of the way up the body. Too high or low gives the *alef* an unbalanced look.

The bottom horizontal of the *bet* extends slightly out beyond the right vertical stem. The left end of the horizontal can meet or extend slightly beyond the left end of the upper horizontal.

The diagonal of the *gimel* is sharper than that of the *alef*. The head shouldn't be too long. The left foot extends out in a walking fashion.

The *dalet*'s roof must be weighted three-quarters to the left and one-quarter to the right of the vertical.

The *heh* is shaped like the *dalet*, minus the short extension. The *heh* has a foot in the lower left-hand corner that extends half the height of the letter.

Vav has a head that extends slightly to the left. Too much of a head will make it look like a *resh*.

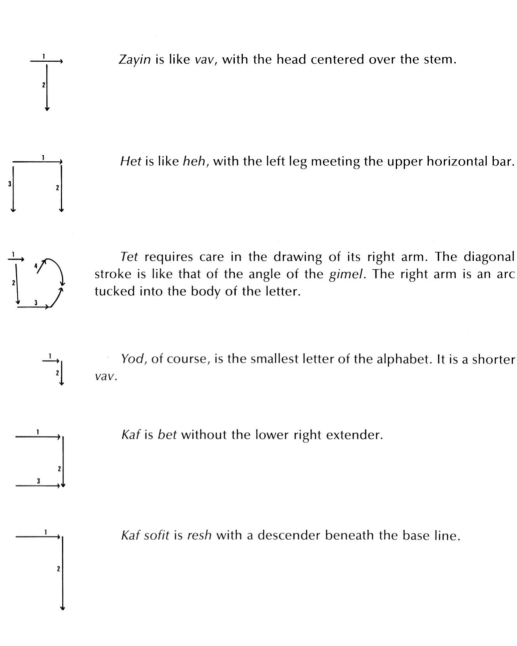

Zayin is like *vav*, with the head centered over the stem.

Het is like *heh*, with the left leg meeting the upper horizontal bar.

Tet requires care in the drawing of its right arm. The diagonal stroke is like that of the angle of the *gimel*. The right arm is an arc tucked into the body of the letter.

Yod, of course, is the smallest letter of the alphabet. It is a shorter *vav*.

Kaf is *bet* without the lower right extender.

Kaf sofit is *resh* with a descender beneath the base line.

Lamed is the tallest letter of the alphabet. It is formed from a *vav* sitting on a *kaf*.

Mem is more difficult to draw well. The *vav* should just barely touch the *kaf*. It must be open at the bottom left. An alternate *mem* is shown as a dotted line.

The final *mem*, the *mem sofit*, is closed. The two verticals are capped on either end with a horizontal.

Nun is a simple letter. It is a *vav* with a bottom horizontal extending beyond the head to the left.

The final *nun*, *nun sofit*, descends beyond the main body line. It is an extended *vav*.

The diagonal of the *samekh* is like the diagonal of the *gimel*. An arc curves from the bottom point to meet the right edge of the horizontal bar.

The left arm of the *ayin* resembles the diagonal of the *gimel*. The right arm, a *vav*, extends into a curve coming up from the bottom. The foot of the *ayin* can be dropped just beneath the baseline.

Pe is a *kaf* holding a *yod* upside down from the roof.

Final *pe*, *pe sofit*, is a *kaf sofit* holding a *yod* upside down from the roof.

 Tzadi is the diagonal of a *gimel* on a horizontal out to the left. A *yod* is attached two-thirds of the way up the diagonal. The base line extends the width of a *yod* beyond the top of the *tzadi*.

 The *tzadi sofit* is a **Y** with two arms wearing heads.

 Kuf is a *kaf* with an extended roof and a descender that reaches into the cavity of the letter. The tail extends two-thirds of the way up the letter's main body but does not touch the foot or the roof.

 Resh is a *vav* with an extended roof.

 The diagonal of a *shin* matches the diagonal of the *alef*. It has two arms, one extending two-thirds up the diagonal. Creating the perfect angle and joining the lines comes with practice.

 Tav is a *resh* with an upside down *vav* as the left foot.

Five letters have a final form. These letters are *kaf, mem, nun, pe,* and *tzadi*. The final form can only be used if the letter appears at the end of a word; otherwise, the regular form of the letter can be used.

THE SHAPE AND SIZE OF THE HEBREW LETTER

Hebrew letters are classified by width, and range from narrow (1) to extra wide (4), as shown in the chart (see also Fig. 3–1).

1		2 ½		3		4	
yod	י	resh	ר	alef	א	mem	מ
nun	נ	heh	ה	tet	ט	shin	ש
zayin	ז	het	ח	lamed	ל	ayin	ע
gimel	ג	bet	ב	samekh	ס	pe	פ
nun sofit	ן	mem sofit	ם	tzadi	צ		
vav	ו	dalet	ד	kuf	ק		
		kaf	כ	tzadi sofit	ץ		
		kaf sofit	ך	tav	ת		
		pe sofit	ף				

Base Strokes

The Hebrew letter can be divided into a top, middle, and bottom. The base strokes of the Hebrew alphabet are:

The *yod*

The *vav—yod* with an elongated tail

The *resh—vav* with an extended head

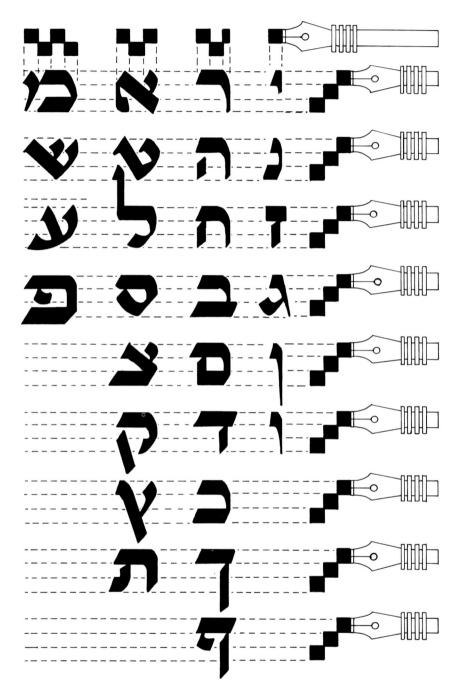

Figure 3–1

Short vertical—found in letters like

ב‎,‏ד‎,‏נ‎,‏ת

Bottom horizontal—found in letters like

ב‎,‏כ

Top horizontal—found in letters like

ב‎,‏ד‎,‏ר‎,‏ך

Diagonal—found in

א‎,‏ג‎,‏ע‎,‏ש

Curve—found in

ם‎,‏מ

The rest of the letter forms grow out of these strokes:

Stem—stroke running from the top to the bottom of a letter

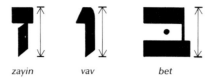

zayin vav bet

Arm—horizontal or diagonal limbs

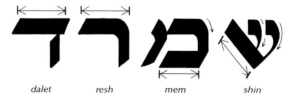

dalet resh mem shin

Bar—arm that joins two parts together

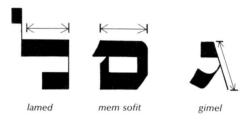

lamed mem sofit gimel

Curve

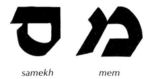

samekh mem

Continuous curve—found in cursive Hebrew

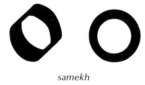

samekh

Serif—shape added to finish off the ends of stems, bars, and curves found on the head or front of letters

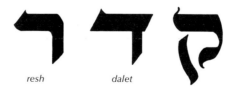

resh dalet

Sans serif—without serifs

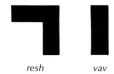

resh vav

Secondary Parts of Letters

Apex

Hairline

Ascender—base height of letter plus a minimum of four pen-nib widths above body of letter

ascender

Foot—end point of letter

foot →

Top Strokes

Descender—the basic height of the letter plus a minimum of three pen-nib widths beneath the body of letter

← descender

Head—initial part of letter

head(s)

Lobe—swell, or curved, tapering part, found primarily in Hebrew cursive

← bowl

↙ lobe

Ball part

← ball part

Swash—decorative ending to a letter

loop

← swash

spur

Tagin—crown, commonly found in *Torah Ktav*

← tagin

Oketz—point, commonly found in *Torah Ktav*

Branch—halfway up

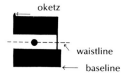

oketz

← waistline

← baseline

Counter—enclosed space, found in *mem sofit* and *samekh*

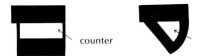

counter

Letters are distinguished by design, weight, width, and axis. *Design* refers to the general appearance of a letter. It is partly determined by the presence of a serif, and the type of serif it is.

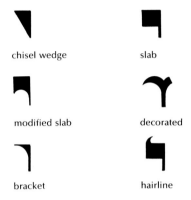

chisel wedge slab

modified slab decorated

bracket hairline

Weight applies to the thickness of the line.

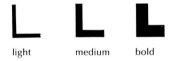

light medium bold

Width refers to the overall width of the letter in relation to its height.

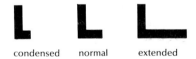

condensed normal extended

Axis refers to the general direction of the letters.

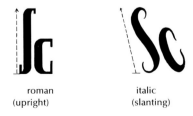

roman
(upright)

italic
(slanting)

LETTER PROPORTIONS

The following charts indicate the proportions of each letter in height and width for a square and a cursive script, and for numerals. These charts should be studied before you begin to practice writing.

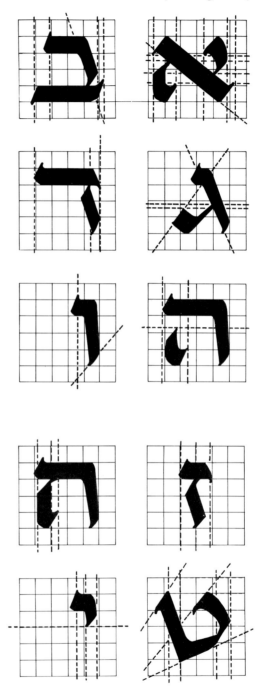

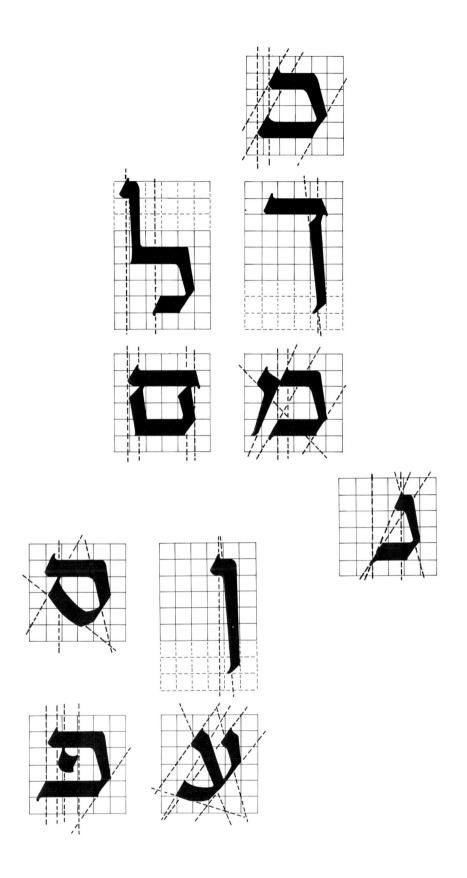

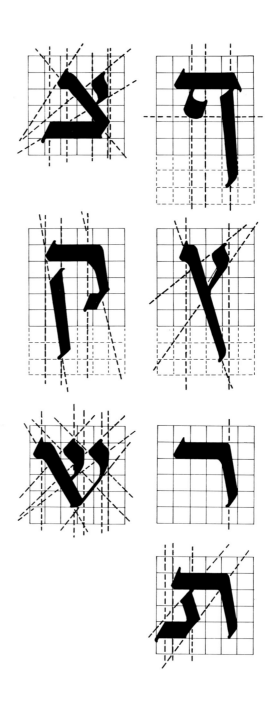

Numeral Chart

WRITING HEBREW SQUARE SCRIPT

You should practice drawing this alphabet (Fig. 3–2), first with a double-point pencil, and then with a chisel-edged calligraphy pen. Notice that the alphabet can be divided into four basic shapes.

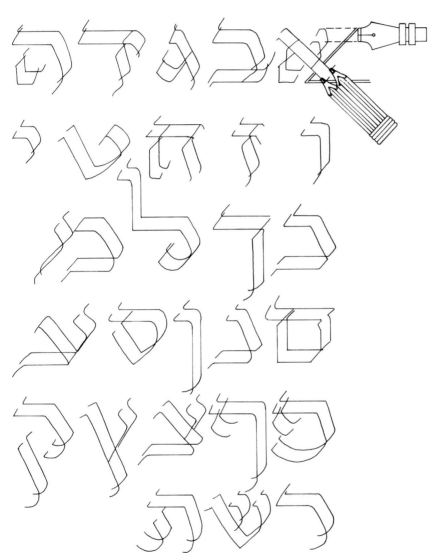

Figure 3–2

בכלמסמפק Letters built on a *kaf* shape

יוזנן Letters built on a *yod* shape

דהחךךרת Letters built with a *resh* shape

שעצעטעגא Diagonals

The standard written letters of Hebrew square script are either three, three-and-a-half, or four pen-nib widths high. Pen-nib widths are determined by holding the pen at 90° to the line of writing and stacking straight strokes, much like marking off an area by placing "one foot in front of the other." Use guide sheets and practice writing the letters by first making the number of strokes indicated for each letter. Follow the directions shown in the illustrations. Do not lift the pencil or pen until each stroke is completed.

Here is the alphabet in Hebrew square script.

Alef is a three-stroke letter.

Bet is a three-stroke letter.

Gimel is a three-stroke letter. Make sure the diagonal is not exaggerated.

Let the head of the *dalet* rest on the stem.

Heh must be drawn carefully. Do not close the left stem to the roof.

The head of the *vav* must not extend to the right over the body or it will look like a *zayin*.

Zayin is a two-stroke letter. The head is centered on the stem.

Het is equal in width to *heh*.

The angle of the second stroke of the *tet* must be held constant and drawn down to the left to create the thin line.

The second stroke of the *yod* must not descend too far beneath the head so as not to be confused with the *vav*.

Kaf is equal in width to *bet*. Do not make the descender of the *kaf sofit* too thin.

Lamed is the tallest letter of the alphabet. It is formed from a *vav* sitting on a *kaf*.

Mem is a difficult letter. Strokes 2 and 5 must not be too thin; stroke 4 must touch stroke 1.

Mem sofit consists of two *resh* joined head to toe.

Nun is a *vav* with a foot. The tail of *nun sofit* must not be too thin or too short.

Samekh is equal in width to *heh* and *het*.

Ayin must be made carefully: strokes 2 and 4 can evolve into a wider stroke at the bottom; stroke 5 comes from the left to the right, touching stroke 4.

Pe and *pe sofit* are equal in width to *kaf* and *kaf sofit*.

If the pen is at the correct angle, distinct changes in line width will be evident in the *tzadi* and *tzadi sofit*.

Stroke 4 of *kof* can be slightly more to the inside of the letter than even with the upper horizontal.

Resh is equal in width to the *dalet*.

The second and third strokes of the *shin* must be splayed slightly. Contrast the thin and thick lines.

The foot of the *tav* can tuck slightly under the body of the *resh* stroke.

Practice the letters. Ask yourself if you've mastered the pen angle. If not, review the beginning instructions. Vertical strokes must not be dominant.

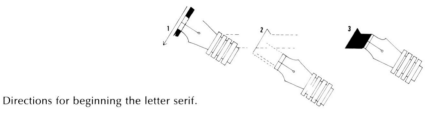

Directions for beginning the letter serif.

POINTS TO PRACTICE

1. Using the "Woman of Valor" (Proverbs 31:10–31), practice a series of clockwise-counterclockwise-motion letters.

2. Learn to discern certain basic forms:

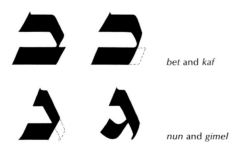

bet and *kaf*

nun and *gimel*

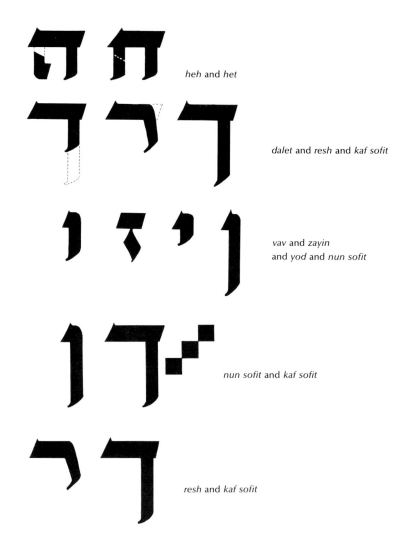

heh and *het*

dalet and *resh* and *kaf sofit*

vav and *zayin*
and *yod* and *nun sofit*

nun sofit and *kaf sofit*

resh and *kaf sofit*

There are very few ligatures in Hebrew writing. This is attributed to the talmudic injunction that "any letter which is not surrounded on all its four sides by parchment is not admitted." An exception is the ligature *alef-lamed*. Sometimes *heh*, *vav*, and *yod* are joined to the preceding or following letter; *mem* and *ayin* may be ligatured with the following letter.

3. In a classroom situation, you can practice on a blackboard with a piece of chalk flattened on one side. This gives the effect of the thick and thin strokes achieved with a broad nib pen. Flatten one side of the chalk by running it repeatedly back and forth on a paper surface. This will help produce a nice even line.

4. All of the principal strokes of the Hebrew alphabet are found in the letters below, so these are useful for beginning practice.

5. Review the letters of the alphabet by writing each letter three times. Underline the letter you feel is best. Check the work with the model, paying special attention to:

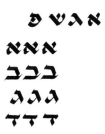

6. Practice letters with vertical strokes of equal thickness.

7. Practice letters with diagonal strokes of equal thickness.

8. Practice the letters with a 45° angle at the bottom of the stroke. Concentrate on making the angle sharp.

9. Practice using steep pen angles on verticals to achieve the spindly look found in Torah writing.

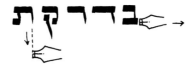

10. If you are having difficulties creating certain letters, go back to the master letter, trace it a few times, and then practice it on a separate sheet of paper. Practice writing a whole line of each letter group.

אבא

גבג

דבד

הבה

ובו

זבז

חבח

טבט

יבי

כבכ

דבך

לבל

מבמ

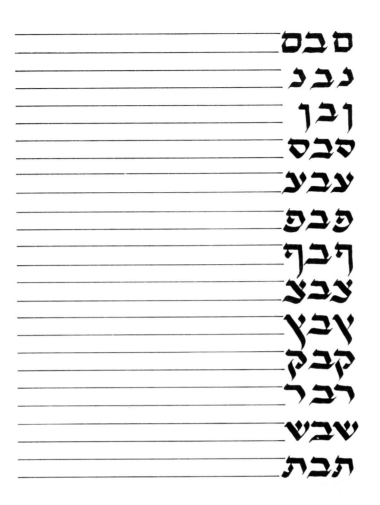

11. Practice single sentences. Be sure to include ascenders and descenders.

קדוש לאנו

Holy to us.

הכלב הלך ברחוב

The dog walked in the road.

12. Practice sentences that extend beyond one line.

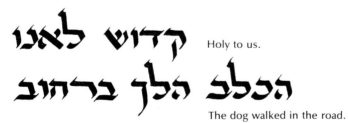

. . . A whip for the horse, a bridle for the donkey, and a rod for the back of fools.

שמע בני מוסר אביך
ואל תטש תורת אמך
כי לוית חן הם לראשך
וענקים לגרגרתיך

. . . Hear, my son, the educating word of your father, and do not forsake the teaching of your mother; for they shall be a garland to grace your head, and a chain about your throat (Proverbs 1:8–9).

DAILY WARM-UP PRACTICE

A daily warm-up of straight verticals and horizontals builds rhythm and fluency and is excellent practice. Most important, it builds beautiful, readable handwriting.

Write the alphabet, five letters at a time, three times each. Analyze each letter, then practice these sayings:

איזה עשיר ...
כל שיש לו אישה
נאה במעשיה

Who is rich? He who has a wife lovely in her deeds (Sabbath).

שקר החן והבל היפי

Charm is deceit and beauty is vain (Proverbs 31:30).

שבת היא ממשים
הבא עולם הבא

Sabbath has a flavor of Paradise about it (Berakhot).

ואהבת לרעך כמוך

Love thy neighbor as thyself! (Leviticus 19:18).

אשת חיל עטרת בעלה

A good wife is a crown to her husband (Proverbs 12:4).

כשושנה
בין החוחים
כן רעיתי
בין הבנות

Like a lily among thorns, so is my beloved among the maidens (Song of Songs 1).

It is far more interesting to practice letters by writing words than just repeating the alphabet. Strive for artistic legibility and neatness. Never allow the descenders of one line to tangle with the ascenders of the next line; lazy letters lose their ideal shape.

To calculate your writing time, choose a thirty-three letter sentence. Write it neatly as many times as you can in two minutes. Multiply the number of letters in the sentence by the number of completed sentences plus the number of letters in the unfinished sentences. Divide by two. This represents your letter-writing speed per minute.

Try and increase your writing speed by starting each line slowly and speeding up as you move along. Do not, however, sacrifice beautiful letter forms for speed. Control of the pen is a case of mind over matter. The determination to write letters clearly and with ease is half the battle. Speed without control reduces the legibility of the letters, and it is never worth the sacrifice.

THE *TORAH KTAV*

Hebrew square script is a calligrapher's dream. The letters are well-proportioned, a combination of stable and cursive forms. Once this basic hand has been mastered, more complex scripts like the *Torah Ktav* can be learned with ease.

Torah Ktav is also known as *ktav ashuri*. There are many laws detailing the exact shape of these letters, and the laws must be followed precisely. Each letter is written left to right; the *pointer* (*oketz*) is drawn with a sideways, downward stroke with the edge of the nib; the horizontal stroke is drawn with a flat left to right pull of the broad side of the nib.

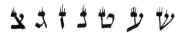

Figure 3–3

The *crowns*, or *taggin*, are special designs that were drawn by a scribe on the heads of seven of the letters (Fig. 3–3). The Talmud tells us that when Moses climbed to Heaven to be taught the Torah and receive the Tablets of the Jews, he saw God putting the crowns on the letters. He watched without saying a word. God asked Moses, "In your home, don't people know how to greet each other?" Moses answered, "Is it not a servant's responsibility to greet his master?" God said, "You could have just wished me success in my labors." Moses answered, "Let the power of God be great according as You spoke." Moses was curious and asked God why He was carving crowns upon the letters. God answered, "There is a man named Akiba ben Joseph who will live many generations in the future who will derive mounds and mounds of laws from each crown." Moses asked God to show him this man. God said, "Go back eighteen ranks." Moses went to where Akiba was hidden and where he could hear the discussions of the teacher with his disciples, but he could not follow what was being said, which disturbed him greatly. He heard the disciples ask their teacher, "From where do you know this?" Akiba answered, "This is the *halakhah* given to Moses on Sinai." Moses went back to Mount Sinai and completed the tablets of stone.

The omission of a tag does not invalidate the text, but its inclusion is an important part of *hiddur mitzvah*, the adornment of a *mitzvah*. *Taggin* should be thin and small. The rounded ends should neither touch each other at the base, nor be attached at the corners of the letters. If two *taggin* are adjacent, they should be close (see Figs. 3–4 and 3–5).

Figure 3–4 Figure 3–5

MEANINGS OF THE LETTER FORMS

Alef

Alef means to be joined, to learn, to teach, to train oneself.

This first letter of the alphabet consists of a sharp diagonal down to the right, a *yod* reaching upwards from the diagonal, with an upside down horseshoe supporting the diagonal on the left side.

By stretching your imagination, you can envision the *alef* as the shape of a man, legs planted firmly apart, squarely under his shoulders. His right palm is raised, pointing skyward.

The *alef* expresses the idea that in order to know the truth, we must join our minds to the inner source of knowledge, emanating from Heaven. This is the reason why the *alef* stands firmly planted, its right hand raised in testimony to God, who is truth and the source of truth,

The *alef* teaches us that truth is not an instinctive quality in man. It is easier to say no than to say yes. It is human nature to lie rather than to fight for the truth, and so truth and a truthful way of living must be learned. One must train oneself to recognize what is true, accept it, and adapt it to one's way of life. "An ignorant man is not righteous" אין עם הארץ חסיד.

Alef is the first letter of the word "truth"— אמת . The letters that spell truth—*alef* א , *tav* ת , and *mem* מ —all have solid foundations on which to stand: two legs in the case of the *alef* and the *tav*, and a leg and a base in the case of the *mem*. Try to push them over—it is not so easy. When one leg begins to move, it is quickly supported by the other leg. The word שקר , falsehood, can easily be toppled. The *shin* ש , the *kof* ק , and *resh* ר each stand on one leg, an insecure base. Touch the letters of "falsehood" lightly and over they fall. Truth, standing securely on two legs, will endure the test of time; falsehood, balancing precariously on one point, will fall over the moment it is scrutinized and opposed. The *alef* implies that if a person lives a life imbued with truth, all his endeavors will have legs on which to stand, and all his undertakings will endure forever.

Bet

The *bet* (pronounced *bayt*) is square, with its length equal to its width. Its corners should be as sharp and clean as possible. The bottom horizontal line of the *bet* protrudes beyond the vertical at the right-hand corner.

Bet can be confused with *kaf* if the top is too round and the bottom line does not protrude out to the right. It can also be confused with *nun* if the horizontals are too short or if the top horizontal is shorter in length than the bottom horizontal and the bottom line does not protrude on the right.

The *bet* has two crowns on the top horizontal bar, one at either end. The crown on the left-hand corner points straight up and the one on the right corner points to the right. According to the Talmud, when the *bet* was asked, "Who created you?" it gestured with the left pointer to the One above. When the *bet* was asked, "What is his name?" the *bet* gestured with the pointer on the right toward the *alef* to say: "*Adon shmo, echad shmo*"—He is the Master Who is One.

Why is the *bet* closed on all three sides—top, bottom, and back?

Why is the *bet* open in the front? To teach us that mankind is not permitted to inquire what preceded this world or what is above or below the limits of our existence. Man should not concern himself with timeless questions that will never be answered, questions like, "Is there life after death?" Man must admit there are questions that won't be answered in this world and limit his quest for wisdom to matters that concern this world. He should not dwell upon the past but rather look toward the future.

Gimel

The body of the *gimel* should resemble a *zayin*, slightly inclined to the left. A foot, *regel*, is attached near the base of the *gimel* by a thick line. The foot should point upward. The letter is considered kosher if the body of the *gimel* is made like a *nun sofit* and if the foot is level with the bottom of the *zayin* , although some consider this an error.

The *gimel* can be confused with the letter *nun* if the foot is connected at the base of the *zayin* . Three crowns are drawn on the top of the *gimel* .

Dalet

The *dalet* has a long roof and a shorter foot. The foot should be inclined slightly to the right. The roof of the *dalet* extends slightly beyond the point where the foot joins it, thus distinguishing it from a *resh* . The foot cannot be too short or it will be mistaken for a *yod* . If it is too long, it will be mistaken for a *kaf sofit* . The Mikdash Me'at considers a straight-legged *dalet* kosher, but the Chesed HaSofer does not. The *dalet* should have a pointer (*oketz*) on the right side of the roof and a *tag* on the left side. The letter is still kosher if the *tag* is missing.

Why is the *bet* open, facing the *gimel*, and the *gimel* open, facing the *dalet*? The *bet* has the appearance of a house with doors open to

everyone who requests entry. The *gimel* has the appearance of a rich man, a *gever* גבר , an upstanding citizen who does acts of kindness. The *gever* is prompted to action when he sees the *dalet* דלת , a poor person, passing the doors of his house. The *gever* runs inside to find food and clothing to give to the poor.

Heh

The letter *heh* is composed of a *dalet* and an upsidedown *yod*. The *heh* should be squared off to the right-hand corner like a *dalet* and extend past the foot. The distance of the *yod* from the roof should not be greater than the width of the roof and the letter is invalid if even a fine line connects the two. The *yod* should be in line with the end of the roof. The inverted *yod* tapers toward the top and should be in line with the foot of the *dalet*. It must face right, not left, or it will resemble the letter *tav*. The foot of the *heh* does not have to lean toward the right, and the roof of the *heh* does not have to have a pointer on the right, thought it has one on the left.

The letter *heh* has two openings, one large and one small. These symbolize passageways. Even the wicked, who leave the ways of this world in pursuit of their evil endeavors, find a narrow door is left open through which they can still return. The way out of this world, the bottom of this world, is represented by the wide-open bottom of the *heh*. Why was this world created with the letter *heh*? Because *heh* resembles a vestibule. This world is a vestibule from which each person has a free will to come and go as he please. If a person chooses to depart from the ways of this world, the door is open before him.

Why does the *dalet* have the appearance of a staff and stand facing the *heh*? Because the staff is the symbol of the poor, whose sole possessions are their "staff and haversack." "With this staff, I pass over this Jordan" (Genesis 32:11). The poor person is looking for the goodness in this world. Some interpret goodness to mean that the poor are optimists, looking only for the betterment of this world. Others interpret goodness to mean the "pot of gold at the end of the rainbow." The poor man spends his whole life searching for physical comforts. A third interpretation is that the poor seek out the *gever* so they may help one another. The *gever* helps the poor person by bettering his financial situation, and the poor person helps the *gever* by allowing him to fulfill the positive commandment of giving charity and *chesed* (deeds of compassion).

This world was created with the letter *heh*, as it is written: "These

are the generations of the heavens and the earth when they were created." It is not to be read, "When they were created," "B'hibaram," but to be read "B'hay-baram," "With *heh* they were created."

Vav

The head of the *vav* should not be longer than the width of the *sofer*'s pen or it will look like a *resh* ㄱ . If the head of the *vav* extends beyond where the foot joins the head on the right, it will resemble a *zayin* ᛏ or a *dalet* ㄱ . The length of the foot should be the length of two pen nibs; if the body length is any longer, it will look like a *nun sofit* ᛁ ; if the foot of the *vav* is too short, it will resemble a *yod* ㄱ .

The corner of the *vav* stands straight like a wooden staff, facing the *zayin* ᛏ . The wooden staff represents idolatry—idols are often created from wood, a representation of the materialistic aspects of the world in which we live, a world dependent on wood for its "support." The abundance of natural resources and man-made derivatives in this world were created for the good of man. This plentitude gives potential to the righteous, who sustain our world with their good deeds. After God created this world with the *heh*, He imbued it with the potential for man to create beauty with the *vav*.

Vav ㄱ faces *zayin* ᛏ , alluding to the future when God will strike down the wicked with the fiery staff of *Gehenom* (Hell) until they cry out, "Woe, woe!" As it is written, "Woe to the wicked doers of evil" (Isaiah 3:12).

Zayin

wrong right

The head of the *zayin* must pass over both sides of the foot. If the foot is more than two pen-nib widths, it will look like a final *nun* ᛏ . The head should be squared at the corner and have three crowns. The body should not grow wider toward the middle and taper to a point. The *zayin* is not kosher if the head is not centered.

The letter *zayin* is said to have two faces. It is the nature of the

zonah, those who have been led astray, to be two-faced about their actions. First, the letter *zayin* casts an eye toward the *vav*. He is governed by the desires of his eyes and his heart, an attribute that will lead him astray. He seeks out idolatry and evil deeds in pursuit of materialistic aspirations. Then he casts an eye toward the *het* (sin) because in the end he will be forced to face his sins.

Het

The *het* resembles two zayins set one pen-nib width apart. The two *zayins* are connected by a chevron. The right side of the chevron is wider than the left because of the angle at which you hold the nib. Do not stretch the chevron out so that it loses its steepness. The left *zayin* has a tag on the left edge. A *het* drawn with a long, horizontal upper bar is still regarded as kosher. One opinion is that a *het* made from a *dalet* and a *zayin* ᵀᵀ , or two *vavs* ᵀᵀ , is still kosher, though it should be corrected, if possible. A second opinion holds that such a *het* is invalid; the *dalet* should be shortened, and the *vav* should be extended to look like a *zayin*. A chevron like ᵀᵀ is not kosher.

The letter *het* wears no crown. It stands naked and exposed, and represents transgressions. Although the transgressor might benefit momentarily from his evil doings and live a better life in this world than the hardworking pious person, he will not wear a crown in the world to come, but rather pay for his sins in Hell. It is the pious person who will wear a crown of glory in the world to come. The letter *het* "opens down," as the wicked hang their heads in shame for their deeds.

Tet

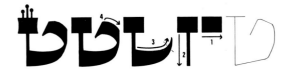

The right-hand side of the head of the *tet* should protrude slightly into its cavity. The upper and lower right-hand corners should be rounded. The two heads must not touch each other. The left-hand head of the *tet* should look like a *zayin* ᵀ wearing three crowns. The right-hand head should be bent slightly downward and should be longer than the head of the *vav* ᵀ , or else it is invalid.

The letter *tet* stands with its head straight, wearing a crown. Its right hand is curved inward, hidden from view. All good deeds and charity come from the heart and are accomplished by the hand. The actions of charity should be done discreetly, in a humble fashion, not in a boastful manner. The primary goal of a gift given in secret is to benefit the recipient, and prevent jealousy and anger in nongivers.

Yod

The face of *yod* should be no wider than a pen nib. Its foot should be inclined to the left, and short, so it doesn't look like a *vav* ‏ן‎ . The *yod* ‏י‎ has a crown on its upper left corner and a pointer on the lower left corner. The pointer should be smaller than the crown and the foot on the lower, right-hand side. If the two are equal in length, the *yod* ‏ן‎ becomes invalid. If the crown is too big, it will become a *lamed* ‏ל‎ .

The letter *yod* is the smallest of all twenty-two in the alphabet. Those who humble themselves in this world and make themselves small like the *yod* will receive a worthy inheritance in the world to come, which was created with *yod*.

God's name can be written with a *yod* and a *heh*. His presence is felt both in this world and in the world to come. Why does the pointer on the *yod* face forward? Every righteous person is rewarded according to his good deeds in this world. It is said, "Whoever humbles himself in this world, is worthy of a portion in the world to come" (Isaiah 58:8). The *tag* on the *yod* points to show that the good deeds of the *tzaddik*, the righteous person, preceded him into the world to come. It is written that "your good deeds shall go before you."

Kaf

The upper and lower corner of the *kaf* are rounded. The letter is kosher if the lower corner is rounded and the upper corner is squared, but it should be fixed, that is, set solid and right—not wavy or wavering. The space between the upper and lower horizontals should be equal in length and at least one pen-nib width apart. The *kaf* should

not be so narrow that it resembles a *nun* ב , so long on top that it resembles a *resh* ר , or so long on the bottom horizontal that it resembles a *bet* ב . The *kaf* should be rounded inside as well as outside.

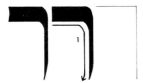

If the roof of the *kaf sofit* (final *kaf*) ך is too long it will look like a *resh* ר ; if it is too short, it will look like a *nun sofit* (final *nun*) ן or *vav* ו . If the tail is too long, it will look like a *dalet* ד or a *zayin* ז .

The tail of the *kaf sofit* should not be so short that it looks like a *yod* י , a *vav* ו , a *resh* ר , or a *dalet* ד . The tail should extend well below the lower line (three ך pen-nib widths) so that it will not be confused with other letters. The roof of the *kaf sofit* should be half the size of the tail, or descender, so that when the descender is bent it will form a *kaf* כ . The corner of the *kaf sofit* should be rounded, though if it is not, it is still kosher.

The difference between the *kaf* and the *kaf sofit* is that one is bent and the other is straight. The *kaf* is used only at the beginning and middle of words, and the *kaf sofit* is used only at the end.

The *kaf* is likened to a throne (*kisay*), prepared and ready for the king.

Lamed

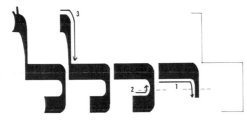

The *lamed* consists of a *vav* perched atop a *kaf* (ו + כ = ל).

The bottom horizontal bar of the *kaf* does not have to be as long as the

upper horizontal. The neck of the *lamed* should be at least as long as a *vav* ٦ , and is invalid if it is only the length of a *yod* ܝ . A *lamed* made of a line perched atop the *kaf* should be fixed so that it becomes a *vav* on top of a *kaf* facing left. The *lamed* is invalid if the line perched atop the bar faces the right ܝ , or if it has no bottom ܝ . The *lamed* has two pointers, on top of the *vav*.

The *lamed* is the only letter in the alphabet with an ascender. It is taller than all the other letters because it is likened to a king, and it sits in the middle of the alphabet, surrounded on both sides by letters, just like a king sitting high on his throne. *Kisay* (the *kaf*) ܒ , with his kingdom, *malkut* (the *mem*) ܝܒ before him, surrounded by his troops who protected him from his enemies.

Mem

The open *mem* is made of a *vav* ٦ and a *kaf* ܒ . The upper right-hand corner should be squared off. The upper and lower horizontal bars of the *kaf* should be equal in length. The *vav* should be aligned with the upper half of the *mem*, and slightly separated, with the foot leaning away from the *mem*. The *vav* should be long enough so that it reaches to the bottom of the *kaf*, but it cannot touch the *kaf* or it will be invalid. The *vav* is kosher even if it doesn't reach to the bottom of the *kaf* ܝܒ . The head of the *vav* must touch the head of the *kaf* to be considered kosher. The heads of the *vav* ٦ and *kaf* ܒ must be separated. If there is no separation, or · between the heads, the letter is invalid ܝܒ , even though there is a separation of the bases. The letter is valid if the *vav* extends as long as a *resh* ܝܒ .

The *mem sofit* (final *mem*) ܡ , sometimes called the *mem* stomach (closed *mem*), is completely enclosed. The upper right corner of the *mem sofit* must be rounded, but care must be taken not to round the corners so that the *mem sofit* resembles a *samekh* ܣ . The upper left hand of the horizontal bar should protrude slightly beyond the

left-hand vertical foot. The *mem sofit* is still kosher if the left edge protrudes more than a pen-nib width, or not at all. The *mem sofit* is invalid if there is a crack in the lower left corner of the base that makes it look like an invalid *mem* 𝕸 .

The letter *mem* follows the *lamed*, the tallest letter of the alphabet. Its head is bowed in admission of the fact that God is the King of all kings. Its hand is raised in testimony to God, "For to God is the *Malkhut*, the kingdom" (Isaiah 22:29).

Nun

The top of the *nun* resembles the top of a *zayin* ⃰ wearing three crowns. The top should not be too wide or it will resemble a *bet* 𝕭 or a *kaf* 𝕯 . The base of the *nun* must extend beyond the roof. The neck of the *nun* should be thick, and descend from the middle of the head toward the right, and the lower corner should be rounded. The roof of the *nun* must be fixed if it resembles a *vav* 𝕵 , and not a *zayin* 𝕷 . The *nun* is invalid if the roof is reversed or missing. The base of the *nun* should not extend so far that it cannot join the top.

The *nun sofit* 𝕴 (final *nun*) looks like an elongated *zayin* ⃰ wearing three crowns. The tail of the *nun* should be no less than four pen-nib widths long, enough to form a regular *nun* when it is bent. The final *nun* extends well below the baseline so that it will not be confused with a *vav* 𝕴 or a *zayin* ⃰ . It is invalid if it resembles an elongated *vav* or 𝕴 . The final *nun* appears only at the end of words, while the regular *nun* is used at the beginning and in the middle of words.

The *nun* faces the *mem*, like a man down on his knees in prayer to God, his King. The *nun* resembles a servant bent in prayer, *nofel*, on his knees, petitioning the aid of his king, *melekh*, as represented by the letter *mem*.

The *nun* is bent in prayer to his King, the Holy One, Blessed be He, "*Somech Noflim*, supporter to the fallen."

Samekh

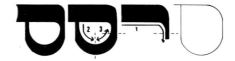

The *samekh* is formed from an upper horizontal bar sitting on top of a U. The left-hand edge of the horizontal extends slightly beyond where the left arm of the U joins the horizontal. All the corners of the *samekh* must be rounded, and it should be completely closed. The *samekh* should taper down somewhat toward the bottom of the U. The *samekh* is invalid if either of the lower corners is squared off,

resembling a final *mem* 🔲 . The *samekh* may be considered kosher if the upper right corner is square or if the top of the *samekh* does not extend out. If the top of the *samekh* is not round and does not extend out, the letter is invalid.

The *samekh* is closed on all sides because when the Children of Israel go before God, the Divine Presence will surround them like a wall of fire to protect them from any intrusion.

Ayin

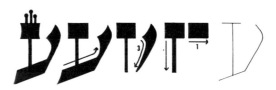

The *ayin* begins with a *yod* whose tail is drawn downward to the left. A *zayin* with a narrow body is connected to the *yod*, and the two are joined by a thick line that gradually narrows to the point where it meets the *yod* and *zayin*. The left-hand head looks like a *zayin* with three crowns. The right-hand head of the *ayin* stands upright. The two heads of the *ayin* must not touch each other ✡, and they must be corrected if they are written just as straight lines ✡. The Ari says that the left arm of the *ayin* could resemble a *vav* wearing three crowns ✡. The *ayin* is invalid if the heads are drawn on the right sides ✡ of the arms, and is kosher if the *zayin* is the size of a *yod* ✡. The *zayin* ✡ must be corrected if it sticks out below the base of the *ayin* .

The letter *ayin* resembles a cripple stretching his arms beseechingly toward the heavens. Its legs are collapsed and shackled, much like a prisoner who is not free to move, and cries out to God to redeem him from his subjugation.

Pe

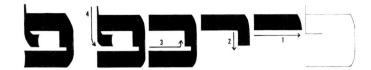

Pe is formed by an upper horizontal drawn with the width of the pen nib, joined on the right side by a vertical drawn halfway down the letter and continued to the baseline by another line, drawn with the edge of the nib. This thin line is connected with a lower horizontal drawn with the width of the pen nib, matching the length of the upper horizontal. The left edge of the upper horizontal is joined to a thin line, and a pointer is drawn with the edge of the nib sideways in a downward motion, starting above the upper horizontal and continuing down to half the width of the letter, then continuing in a horizontal stroke down with the width of the nib. The latter stroke extends into the letter one *vav* wide.

The lower corner of the *pe* should be round on the outside but square on the inside. The right side of the *pe* protrudes inward so the cavity resembles a *bet*. It is incorrect for the right-hand vertical to protrude outward. An inverted *vav* is attached to the upper horizontal. The letter is invalid if the head of the inverted *vav* touches any of the horizontal or vertical bars of the *pe*. If the head of the *vav* resembles a *yod* and sits behind the *pe*, the letter is still kosher. If the *yod* is reversed, or if the tail of the inverted *yod* does not touch the upper horizontal bar, the letter is invalid .

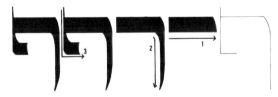

The *pe sofit* (final *pe*) is formed from a *kaf sofit* joined on the left-hand edge by an inverted *vav* . It must be long enough to form a regular *pe* when bent. It must extend at least the length of a *yod* past the inverted *vav* . The head of the inverted *vav* cannot be reversed, or else it will resemble the letter *tav* . Do not forget to put the head on the inverted *vav*, or it will resemble the letter *het* .

The letter *pe* sits on the base of a horizontal bar. It is topped with a second horizontal bar from which an upsidedown *yod* is suspended.

Pe means "mouth." Man can be bound or freed by his mouth. If

used properly, his mouth can open the way before him, opening doors to a good future. If used unjustly and to hurt others, his mouth can cause doors of advancement to close in his face.

The letter *pe* closely follows the letters *samekh* and *ayin*: *podeh*, redeem, and *poteach shaarim*, open the gates. God redeems those who are bound, and frees those who call out His name. A prisoner in a cell waits anxiously day after day for a jury's verdict. When he calls upon God, recognizes his faults and evil ways, and opens his heart to God and repentance, God opens the gates of bondage and releases the prisoner.

Tzadi

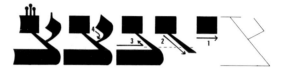

The *tzadi* resembles a *nun* ![nun] with a *yod* ![yod] attached to it. The *yod* points upward. If the *yod* is attached closer to the base of the *nun*, it will resemble an *ayin* ![ayin] . The left head of the *tzadi* resembles an *ayin* wearing three crowns. If the two heads of the *tzadi* touch each other ![symbol] , the letter must be corrected. The letter is invalid if the *yod* is only a thick line ![symbol] . The Ari says that the right-hand *vav* should be reversed and the left-hand head should be a *vav* with three crowns on top ![symbol] . It does not matter that the two styles of *tzadi* contradict each other—sometimes written like the regular Bet Yosef script, and sometimes like the Ari script.

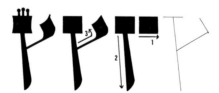

The *tzadi sofit* (final *tzadi*) is made like a *nun sofit* ![nun sofit] and a *yod* ![yod] . The *nun sofit* should be long enough so that if it were bent, it would form the regular *tzadi*. The tail should extend well past the point where the *yod* is attached. The Ari allows the right arm of the *tzadi sofit* to be reversed. The *yod* preferably is attached to the upper half of the *tzadi sofit*, though it can be attached farther down on the stem. The regular *tzadi* is placed at the beginning or middle of a word, never at the end. The *tzadi sofit* ![tzadi sofit] is used only at the end of a word.

The letter *tzadi* is bent over, bowed down. It can be likened to a

tzaddik, a righteous person, carrying himself in a humble way, subduing his evil inclination. The righteous bow before the Creator. Aware of God's presence, the righteous will suppress the desire to do evil. As it is written, "I have set the Lord always before me. Surely He is at my right hand, I shall not be moved" (Psalm 16:8).

A person who sees God will do no wrong because he will fear Him. God will be at his right hand to guide and help him. The *tzadi sofit* stands straight to represent the righteous, who are bent over in this world but will stand straight and be glorified in the world to come.

Kuf

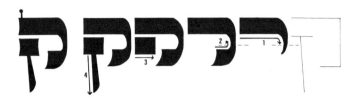

The *kuf* resembles a *kaf* with a slightly shorter lower horizontal bar ⌐ . Under the upper horizontal on the left side sits a *nun sofit* without the crowns. A crown sits on the upper left corner of the *kuf* ק . It should not be too long or the *kuf* will resemble a *lamed* ק . The *nun sofit* must be a pen-nib width away from the upper horizontal bar. The *kuf* must not touch the *nun sofit* ק ק .

The *nun sofit* is inclined slightly to the right. It is in line with the end of the roof but must not touch it. The laws regarding *kuf* are similar to the laws concerning the *heh*: the tail of the *kuf*, shaped like a *nun sofit*, should be 3½ pen-nib widths high ק . *Kuf* is considered kosher if the tail is a *vav* ק shape or even a straight line ק , or if the body is made from a *resh* ק . The letter is kosher even if the tail is not aligned with the upper horizontal of the *kuf* or if the tail ק extends beyond or below the main body of the *kuf* ק ק .

Kuf is the first letter of the word *kaseh*, holy, in the morning prayer, the *Shmoneh Esre*. We say, "We will sanctify Your name in this world." And the Bible says, "That one angel calls out to the other angel, calling 'Kadesh.' All the angels join in unison and declare, 'Holy is the Lord of Hosts'" (Isaiah 6:3).

Resh

The *resh* is a *vav* with an elongated horizontal bar. The corner of the *resh* must be rounded and extend beyond the foot . If it is square, the *resh* will be confused with a *dalet* . The leg of the *resh* should be short enough that it does not resemble a *kaf sofit*

 but long enough that it does not look like a *yod* .

Resh is *Rashah*, the wicked. Why does the *kuf* hide its face from the *resh*? Because God cannot bear to look at the wicked! Yet why does the top horizontal bar of the *kuf* wear a crown pointed toward the *resh*? Because God gives the wicked an opening through which to return to a proper and benevolent way of life. God invites the wicked to repent their evil ways, and offers to place a crown like His upon their heads as a reward.

Shin

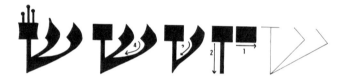

The *shin* has three heads. The right-hand head is like a *yod* , the middle head is like a *vav* , and the left-hand head is like a *zayin* wearing three crowns on its roof. The body of the *zayin* should be vertical , though some *sofrim* slant it. None of the heads must touch any of the other heads . A *shin* is kosher if all the heads are zayins . A *shin* is invalid if it has four heads , if two or all of the three heads are reversed , or if it has a rounded base .

The letter *shin* has three heads, but no foundation to root it below. It is the first letter of *sheker*, falsehood. *Sheker* is all talk but has no legs to stand on. It is easily proved wrong and in the end does not endure. God promises that in the future, He will shut the mouths of the ones who speak falsely. Eventually, lies catch up with the bearer of false tales.

Tav

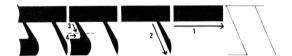

The letter *tav* resembles a *dalet* ⸵ joined with an inverted vav. ⸵ The right-hand leg should not be too long because it will look like a *pe sofit* ⸵ . The letter is invalid if the left-hand leg is the size of a small *yod* ⸵ , or a straight line (because it will resemble a *het*). The letter is kosher if the letter is like a *resh* ⸵ and a *vav* ⸵ . The letter is invalid if the roof is short like a *vav* ⸵ or a *zayin* ⸵ . The leg should be made of an inverted *dalet* ⸵ .

The letter *tav* is the final letter of the alphabet. *Tav* is the letter of truth, *emet*, **אמת**, and the letter of Torah, which is Truth. Why must the foot of the *tav* be bent? Whoever wants to learn the Torah of Truth must fold up his legs and sit occupied in study. As it is written, "They sit down at Thy feet receiving of Thy words" (Deuteronomy 33:3), just like the *talmidim*, the students, who sit in the presence of the Master ready to receive instruction.

Shin-tav

Shin stands for *sheker* **שקר** , falsehood; *tav* stands for *emet*, truth **אמת** .

Why are the letters of *sheker* close together while the letters of *emet* far apart? Because falsehood occurs frequently and truth is spoken rarely. Falsehood reflects only a small amount of facts, so it is represented by a few letters grouped together at the end of the alphabet. The letters of *sheker* are out of order (*shin* ⸵ , *kuf* ⸵ , *resh* ⸵), according to their order in the alphabet (*kuf* ⸵ , *resh* ⸵ , *shin* ⸵). The facts of a lie are rearranged in order to suit the needs of the lie. The letters of the alphabet are rearranged to spell the word for falsehood.

The letters of truth, *alef* ⸵ , *mem* ⸵ , *tav* ⸵ , are in the same order in which they appear in the alphabet. Truth encompasses everything from **A** to **Z**. *Alef* comes first, *mem* is in the middle, and *tav* is the last letter of the alphabet. The one who speaks the truth can defend himself against any challenge without rearranging the facts.

HEBREW CURSIVE SCRIPT

Hebrew cursive script is an informal script with a narrow form. The steeper slope of the letters is the result of writing with greater speed. The body height of the letters is five times the width of the nib; the ascenders and the descenders can be the same height as, or longer than, the body. Lines of cursive writing must be spaced farther apart to avoid tangling one line with the next.

Cursive script is often flourished, but you must be careful not to overdo it. One or two well-placed flourishes decorate the page; too many make the page look confusing. You should strive for an evenly patterned black and white page. While spaces inside and outside the letters should look equal. Your flourishes, which should be used only to complement a letter, word, sentence, or page, should not hamper the letter form; they do not make a letter more legible or improve a poorly drawn letter form. They do, however, add balance to letters and artwork. It is just as important to know what to leave out as it is to know what to put in.

Primary Elements of Cursive Script

spiral

oval

circle

bracket

dash

comma

swelled curve

curved line

straight line

swelled stroke

Practice

1. Rule guidelines at 123° angle.

2. Plan, sketch, and lay out the word(s) in pencil on tracing paper.

3. Cover the back of the tracing paper with graphite.

4. Trace the design onto the Bristol board.

5. Ink in the letters.

ORNAMENTAL CAPITAL LETTERS

The earliest recorded Hebrew manuscripts consisted of lines of straight writing with few, if any, paragraphs or chapters. There was no vowel system or pauses within the text. Important words were distinguished by letters drawn larger or smaller than the other words in the text, or by inverted letters.

A vowel system was instituted into the consonantal alphabet to allow the reader to pause while reading lengthy passages. Division of the text into paragraphs was made by slight indentations in the text. The next step in the evolution of written text was the placement of the first letter of a new paragraph in the margin, drawn larger than the rest of the letters in the word, so that the new paragraph would be immediately noticeable. Titles, important words, and important letters, such as first letters, called versals, were written in larger letters (see Fig. 3–6).

Figure 3–6

Figure 3–7

Scribes began to concentrate more on capital letters. They added flourishes, and decorated and colored to make them more ornamental, but still functional (Fig. 3–7). The beginnings of verses, paragraphs, poems, and phrases were distinguished with large, colorful ornamental letters.

The normal shape of capital letters can be curved, flat, or slightly tapered (Fig. 3–8). Keep these points in mind.

1. Care must be taken to preserve the form of the letter, not to exaggerate and thus produce an inferior letter shape.

2. Letters of the same importance should be kept the same size.

3. The more important the letter, the more complex and decorated it can be. Sometimes, an initial letter will contain the rest of the word within it.

4. The first letter of the first word can be enlarged but it is easier to read a word in which all the letters are enlarged, rather than just the first one.

5. Enlarged letters accompanying smaller ones are dropped below the writing line so the top of the letters are level with the tops of the small letters.

Figure 3–8

6. Colored capitals are easily spotted within a text. Two different effects can be achieved—one by using the same color throughout, the second by using different colors. Make your colored letters decidedly larger than the text, because black is stronger than any color, so when a colored letter and a black letter are side by side, the black letter appears much larger.

7. Large letters can easily be drawn with a double-edged pencil. The pencils should be kept at the chosen constant angle. The distance between the two points can be increased with a cardboard wedge placed between them.

Drawn letters give the artist a chance to improve his design creatively without damaging its basic form. Drawn letters and words should be carefully planned on tracing paper before they are committed to the final writing paper. Experiment with line thicknesses, stem endings, and pen angles. The style of lettering must complement the intention of the text: a love poem will have sweeping, delicate lines while a selection from the Torah will have static, solid lines. There is a finite number of existing styles of calligraphy, but the potential for developing new ones is limitless.

Research is a very important part of designing. Artists can borrow ideas here and there, while taking care not to copy another artist's design.

Sometimes, when I am at a loss for ideas, I pick books off my shelf to find a suitable English alphabet to adapt for Hebrew. When I find one I like, I photocopy it. It is easier to work with a single flat sheet of paper than to juggle a book. I twist and turn the sheet so I can find recognizable shapes. Here are four Hebrew letters that have shapes taken from the boxed letters in a nineteenth-century English decorative alphabet (Fig. 3–9).

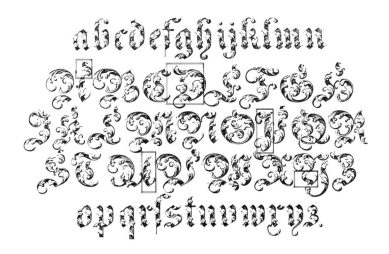

Figure 3–9

TRANSFERRING ORNAMENTAL LETTERS

Do your loose sketching with a pencil on tracing paper. After you have decided on the lines you will follow, finalize the pencil lines by going over them with a fine-point felt-tip pen. Attach the tracing paper to the final board. Slip the graphite-covered paper between the two and trace over the drawn letters with a ballpoint pen. Remove the tracing paper. Wash your hands thoroughly so you won't smudge or dirty the page with loose graphite particles.

With a technical pen, trace over the pencil lines, committing the final black line to the paper. Wait until the ink is dry. Rub away superfluous pencil lines with a kneaded eraser. After the outer edges of the drawn letters are inked, fill them in with black, gold, or another color.

At this point, stop and ask yourself whether the letters are drawn so that the enclosed spaces within them represent the form or the outside of the letter.

Figure 3–10

I prefer to ink the drawn letters from the outside in, though others prefer to work from the inside out (Fig. 3–10). Begin with a full stroke between the outlines. When inking the drawn letters from the outside in, the stroke should not reach the edges on either side. Work from the stroke out to one of the edges. Repeat on the other side. If you have difficulties in drawing the right-hand edges properly, and you are working on a small board, turn the board around. I find it easiest to ink in all the left sides, then all the right sides, all the tops, and then all bottoms.

COLORING ORNAMENTED LETTERS

Rubricating, the artful combination of red and black text, gives a sharp contrast, highlighting important words. The red must be handled strategically throughout the text; the page loses its effectiveness when too much red is scattered indiscriminately in the writing.

Gold-colored capital letters give the page a rich look, reminiscent of ancient illuminated documents. Classes in the application of gold leaf are available through the Society of Scribes and some adult education programs. However, most calligraphers are just as happy with the "gold" that comes out of a bottle of Windsor Newton Gold®. Shake and stir the solution well, then let it sit in a paint dish until it attains the consistency of thick soup. Maneuver the gold-painted area under a fluorescent light to make sure the paint is evenly distributed. If the paint is too thick it will be hard to apply and will leave lumps. These can easily be smoothed out with a damp brush. If the paint is too thin it will cover the paper unevenly. If two or three coats of gold ink are applied, you can achieve a burnished effect.

Mark distinctive areas in red ink, but remember that too much red tires the eye. Use two or more colors to distinguish important words.

CHAPTER 4

SPACING THE LETTERS

The alphabet consists of twenty-two repeating elements in a curious band of design. Each letter is given space according to its degree of complexity, the interest of its shape, and its value as part of the whole design. There is a certain uniformity to the letters: each letter has at least one heavy stroke, and the strokes are placed in a recurring pattern of light to dark strokes, which tends to give harmony to the piece as a whole. The width of each letter is determined by its shape and its place in the overall design.

HOW TO MEASURE LETTER HEIGHT

Pen nibs come in different sizes—broad, medium, fine, and extra fine—and different widths (Fig. 4–1). Nib width, the widest single stroke possible with a particular nib, determines "pen scale." Pen scale is measured as 3, 3½, 4, and 4½. Remember that this is a square script. Thus, if the pen scale is 4, the height of the letter will also be 4 (that is, four pen-nib widths).

Measure pen scale by turning the pen so that the edges are perpendicular to the line of writing. Make short strokes showing the

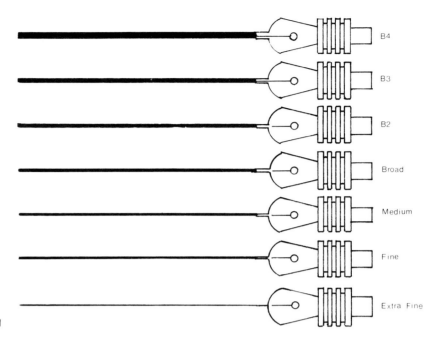

B4

B3

B2

Broad

Medium

Fine

Extra Fine

Figure 4–1

widest stroke of the pen. Stack the wide strokes on a diagonal with the corners touching (Fig. 4–2).

Spacing is a matter of feel and taste. Lines on a page should be spaced to create balance (Fig. 4–3). If the spacing is set mechanically the effect will be poor. For maximum legibility and a balanced appearance, the white space both within and surrounding the letters must be thoughtfully planned.

You can become familiar with pen spacing by practicing the simpler letters of the alphabet. As you draw each line, be conscious of the spaces already made. Conform the new letters to the old. Look at what you are writing, paying attention to the spaces you are leaving between the lines. Feel free to trace over copy by writing directly on the model. Discover the pattern set at the beginning of the line and copy the entire line. Make the copy look exactly like the model.

It is an optical illusion that areas of white between curved letters are the same as areas of white between two uprights.

Letters that are open on one side present a problem because the eye automatically joins the inside shape of the letter with the space between it and its neighbor. These open-sided letters tend to be placed closer to adjacent letters to compensate for the optical illusion of extra space. This cannot be done by formula. It is a simple matter of good taste and judgment.

Curves that are set too far apart allow too much white space to show through. Heavy letter stems that sit too close together appear as a dark blob. The unevenness of the written line affects the overall look of the page.

Figure 4–2

Figure 4–3

Here are a few rules of thumb to follow when spacing letters within words.

1. The greatest distance is left between two straight strokes as in

2. A curved stroke next to a straight stroke is a little closer as in Hebrew cursive or square Hebrew.

3. Two curved lines lines are placed together as in

4. A point or a curve can be tacked under as in

5. Two points are placed as close together as possible, yet still remain separated by a hairline as in

Letters with both top and bottom horizontals should not be extended. Extending such letters (*bet, kaf, mem, mem sofit*) creates an overpowering amount of black (see Fig. 4–4). The eyes perceive the black lines as closer together than they really are, giving the word a heavy black feeling. Perpendicular lines set the standards for spacing.

Figure 4–4

Words like

have too much white inside and between letters. Instead of closing up the letters to get their overall graphic content, the lines are relaxed a bit in their spacing.

The skill of even spacing should be learned while practicing the skeleton forms of the letters. Your eyes will become accustomed to even spacing. The exact measurements might vary slightly when you use an edged-pen.

Practice these words for spacing:

כלב (dog)

חתול (cat)

סוס (horse)

תרנגולת (rooster)

Letters that divide the space they occupy horizontally give the appearance of being narrow. Practice:

א (alef)

ג (gimel)

ט (tet)

ע (ayin)

ש (shin, sin)

Gimel, vav, zayin, yod, nun, and *nun sofit* are classified as narrow letters.

Daled, heh, het, resh, lamed, tav, and so forth are wide letters.

Shin, pe, and *mem* are extra wide letters.

SPACING

Good Hebrew lettering has a sense of stability. The space between words should be about the size of one wide letter. Initially, you might feel more comfortable drawing (lightly in pencil) a circle or square between the words that is equal in width to the height of the guidelines. The average space between two words is less than the width of a circle or a square. The wider the spacing between letters, the wider the spacing between words. The wider the spacing left between letters and words, the more white space must be left between lines. If the spacing is narrow, words can be brought closer together— that is, the left side of one stroke can be closer to the left side of another stroke. The number of words per line is determined by the copy to be lettered. It is up to you to determine the pen scale of the letter to be used.

Improper spacing gives a staggered look to the page, with an uneven spotting of white between the letters, causing dark and light areas in the word. Eye movement is uneven across the page—fast across the dense areas and slow across the open areas. Proper spacing allows the eye to travel with ease while reading.

Lines of writing should form a pattern of strong, regular bands of color, interspersed with bands of paper. Spaces and interspaces (spaces between spaces) should appear to be the same height (Fig. 4–5). Avoid visual "rivers" of white running down the page; rivers are vertical or diagonal rows of white or black caused by ascenders and descenders, words, or spaces between words coinciding in patterns. Extenders, elongated upper horizontal bars, are used to give an even texture to the word and the page. The elastic letters can be changed without changing their family resemblance (see Figs. 4–6, 4–7, 4–8).

Figure 4–5

Figure 4–6

דהחרלת

Figure 4–7

ד

ה

ח

ר

ל

ת

Figure 4–8

The usual distance between lines of writing is three times the height of the space between words. Descending strokes of the upper line must clear ascending strokes of the line below. Rule the space between your lines with a pencil and ruler. Some calligraphers write out the text first in pencil and then trace over the guidelines with the calligraphy pen. It is twice the work, but the effort enables the calligrapher to set his type perfectly.

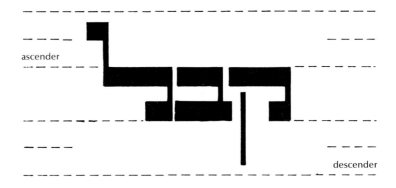

Despite all the rules for the spacing of letters, words, and lines, the eye is the final critic. Rules help, but the eye is the best judge of an even distribution of space and color throughout the text.

Hebrew letters are top-heavy. Traditionally, scribes used only a top guideline. The beginning Hebraic calligrapher should use two guidelines, spaced as shown.

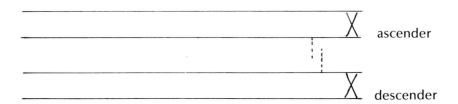

Top and bottom guidelines give the eye visual borders to work within, making it easier to produce straight and square letters. Numerals, if used, are written in the equivalent letter form.

The points and curves of letters must overlap the guidelines a bit to satisfy the eye, so that they appear to sit on the line instead of under it.

The "counter," that is, the space inside letters, must be consistent. If two strokes of the *het* appear closer together than the two strokes of the *heh*, more black will appear in the ח than in the ה and will upset the balance of the line.

שוחט
wrong

שוחט
right

שוחט
wrong

חתפה right

חתפה wrong

The strong black vertical lines at the top and bottom of the letters define the space contained within the letter. Practice these forms:

Do not lift the pen for the curve.

בשׁלוֹן

סימן

שׁישׁון

Common faults include slanting the vertical line or hooking the ascenders and descenders and failing to align the tops and bottoms of the letters. This gives the page an uneven look. Write carefully between the double lines, concentrating on the lines themselves. Make the letters slightly overlap top and bottom. Pause and ask yourself if the spacing is even.

Turn the page upside down and check the spacing and the appearance of the letters.

Easiest: two parallel strokes

וויׄת small hook

וולְקן vulcan

וודְקה vodka

וודֱבִיל vaudeville

More difficult: two curves

לִיׄטמוס litmus

סַס moth

סְסגוׄנא crimson

סְמרטוׄט Aramaic for rag

Intermediate: one straight, one curved stroke

suffix סוֹפִית

storm סוּפָה

horse סוּס

bookworm לוֹמֵתִי

Most difficult: mixed plus interior spaces

merrymaking בַּדְחָנוּת

office מִשְׂרָד

aunt דּוֹדָה

perch אוֹקוּנוּס

תַּרְעָא Aramaic for door, gate

Another fault is failure to keep the space of the square letter between words. Too much space tends to push the writing apart. The horizontal flow of movement of the reading eye is interrupted by vertical white rivers running through the writing.

It is good practice to clean away superfluous lines so they don't interfere with the examination of forms. Stand away from your work every so often. Criticize it for errors in writing and spacing. Make sure each letter has its proper width and all heavy strokes are uniform. Examine each word as a whole, and also as a collection of individual letters, each done one at a time.

I was taught to turn my artwork on its side and upside down, to help me look more objectively at the marks and shapes on the page, as opposed to staring at recognizable letters. Upsidedown letters are not recognizable and become geometric shapes, thus allowing the eyes to concentrate on the spacing patterns. Dark patches appear where the verticals are crowded letters. Try to achieve your own system. Leave enough space between ascenders and descenders so they do not clash.

Practice the following letters in width groupings.

 1. Use a B2 nib.

שמ שמפ לס חרהד
יין ין רסלכח דר שפ
וגו

 2. Practice them across the line.

ותוספתא דא נדוניא דין

 3. Write an alphabet sentence leaving the width of a square between words.

הוצית והצלתי
גאלתי ולקחתי

קול ששון קול שמחה
קול חתן קול כלה

Occasionally, rule a vertical line with light pencil among the letters to check the straightness of the verticals and spacing (Fig. 4–9). Spacing relates to the width of the square chosen for the letters. The width of the square is one-half the height of the letter. Spacing is measured consistently from the right side of one stroke to the right side of the other stroke (Fig. 4–10).

Figure 4–9

Figure 4–10

Sometimes, for decorative purposes, letters can be spread out, but not so far as to obscure the reading of the words (Fig. 4–11).

Figure 4–11

Figure 4–12

Be careful that letters do not touch each other (Fig. 4–12). Interlocking ascenders and descenders can easily be avoided by extending letters in the line above. Here are three solutions to the problem:

1. Extending the *resh*

2. Extending the *lamed*

3. Increasing the space between the writing lines

ראובן
שמואל

FINAL NOTES ON SPACING

1. First practice writing the simpler letters of the alphabet to become used to even spacing. Draw the letters slowly to establish the feeling of the letters and maintain their ideal shapes.

2. As you write each new word and line, be conscious of spaces already made. Make new spaces that are in keeping with the old spaces.

3. Look at and be aware of the letters you are writing and the spacings you are making between the letters and the line. (See Figs. 4–13, 4–14, 4–15, 4–16.)

<p align="right">שׁ , ע , ט , ג , א</p>

<p align="right">א</p>

<p align="right">ג</p>

<p align="right">ט</p>

<p align="right">ע</p>

<p align="right">שׁ</p>

<p align="right">Figure 4–13</p>

<p align="right">שׁ פ מ פּ שׁ</p>

<p align="right">מ</p>

פ

ש

Figure 4–14

ג,ו,ד,י,ב,ן

ג

ו

ד

י

ב

ן

Figure 4–15

ב

Figure 4–16

SEVEN PRIMARY FEATURES OF GOOD WRITING

Determine the character of the writing by

Angle Ia. 30°. The angle of the nib's edge relative to the horizontal line of writing

Weight of the letters: defined as the width of the letter in proportion to the height of the letter

Shapes of the letters: influenced by curves and finishes of strokes

Number of strokes required to build individual letters

Order of strokes

Direction of strokes

Speed of writing; it is important to work at a moderate speed. Working too fast encourages sloppy letters. Working too slowly encourages shaky letters.

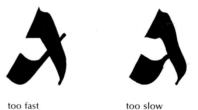

too fast too slow

The constant angle is the angle determined by the thinnest stroke, relative to the writing line. It sets the positions of the nib relative to the line of writing. The constant angle dominates the position of the series of strokes in a letter, word, phrase, sentence, or manuscript, thereby indicating where strokes of certain weights will fall and how the strokes in various positions will be weighted (Fig. 4–17). The constant angle influences what parts of letters will be emphasized and determines the overall look of the manuscript. The thin strokes all lie at the same angle, as do the thick strokes (see Fig. 4–18).

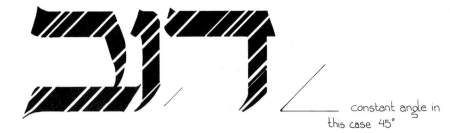

constant angle in
this case 45°

Figure 4–17

𝕬𝕭𝕮𝕯𝕰𝕱𝕲𝕳𝕴𝕵𝕶𝕷𝕸
𝕹𝕺𝕻𝕼𝕽𝕾𝕿𝖀𝖁𝖂𝖃𝖄𝖅

a a b c c d e f g h i j k l m n o o p q
r r ſ s t u v w ẛ y z ꜩ ꜩ

12345 Erinnerung 67890

Figure 4–18

PART III

DESIGN AND LAYOUT

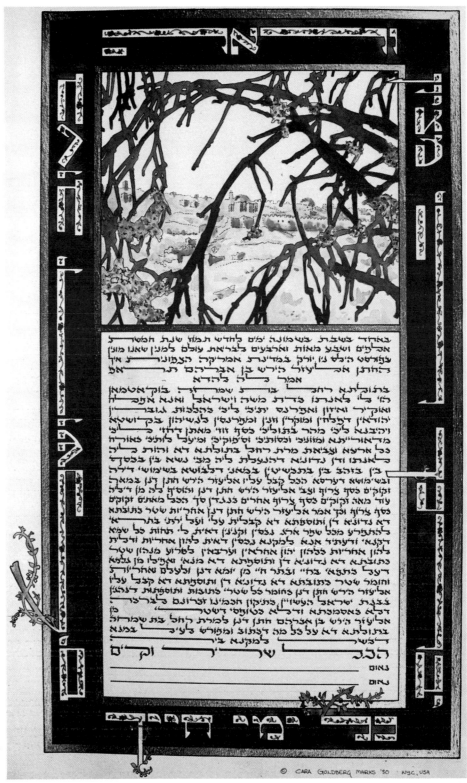

Wedding contract. From the artist's private collection.

CHAPTER 5

DESIGNING THE BORDER

Frequently I hear my students complain, "I can't draw. I'll only be able to write and be limited in the jobs I can accept." Poppycock! Anyone who wants to can draw. It all depends on the effort you want to put forth.

There is beauty in the handwritten page, but there is grandeur in the illuminated page. Decoration may imply something that is tacked onto the page, rather than artwork that complements the writing. The art and writing must be considered together. The design puts the finishing touches to the writing. The design should involve a limited number of elements that are pure in a form and color.

As a child, I thought artists drew pictures straight from their heads; as a student, I learned that artists rely heavily on aids—pictures, photographs, and models. As a commercial artist, I do the same—motif research. Motif research is a sophisticated way of saying that an artist conceptualizes an idea, then refers to photographs and models to see how the subject exists in nature, and looks at other artists' works to see how they handled similar situations and design. Motif research, however, is not a license to copy.

Novice artists often are frightened by motif research. I find it the most fascinating part of my work. It's simple. Everywhere you look you see designs, logos, and monograms—in books, magazines, periodi-

cals, on billboards, television, in food packaging and clothes. Look at company logos, ads in newspapers, book covers, album covers, clothing tags; the list is endless. Dover Publications (31 E. 2nd St., Mineola, NY, 212-255-3755, 516-294-7000) markets a series of design reference books, and Sunday newspapers are a treasure trove of ideas. Keep records of "solutions" that appeal to you; file them alphabetically and categorically, so you can find the designs when you need them. While you can't copy the designs, you can refer to them for suggestions. Turn them upside down, all around, flip them over, change the arrangement, combine two or more designs. In short, be original. Your client isn't paying you for someone else's work, and you don't want to be remembered as a copier.

Every piece I create is designed to a client's specifications and is different from everything else I've done. As much as possible, each piece reflects the personality of my client. I literally interrogate a client about his or her likes, dislikes, hobbies, habits, dreams, favorite colors, preferences in shape—anything that will help me customize a design. Some clients have very definite ideas, while others leave it entirely up to me. Then, when I am ready to begin motif research, I review all my notes and organize them in a logical pattern. If you follow this approach, you too will begin to get ideas for shapes and designs.

DRAWING THE DESIGN

Draw rough sketches of the border as you envision it, and make notations of the elements you will use, and where they will go. Clip pictures from magazines and mark pages in books in which you've found design ideas. On your rough sketch, make notes regarding your motif research; this will save you time. In pencil, on a clean sheet of tracing paper at least two inches larger on all sides than the paper needed for the design, rule the guidelines that will delineate the borders of the artwork. Consider the elements that you want to include in the work and mark their positions with circles. Roughly sketch the design and keep refining it until you are satisfied with its look. The design can be a few simple shapes—a circle, a leaf, a tendril, or a few flourishes and strokes. The key requirement is that it must cover the design space evenly, in a pleasing arrangement expanding from a central point (see Fig. 5–1).

You can work the various elements on separate pieces of paper and position them under the tracing paper until you are satisfied with the composition, at which point you can trace them onto the master sheet. A white piece of paper placed under the element to be transferred makes the marker or pencil lines more visible (Fig. 5–2). Planning your design on tracing paper will settle doubts about the actual layout.

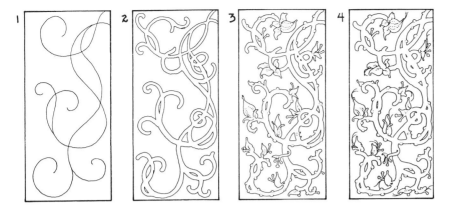

Figure 5–1

When the final layout is done, trace over the pencil lines with a black, fine point, felt-tip marker (Fig 5–3). If you do not go over the pencil lines with a marker they will become lost in the camouflage of the graphite backing or be rubbed off the tracing paper's slick surface. Another option you have when you are ready to transfer the design to the final working paper is to take a slick-surfaced paper that is not too thick, like bond paper from a copy machine, and cover one side with graphite, forming a type of carbon paper. Slip the sheet of graphite-covered paper between the design paper and the art board, graphite-side down. Trace over your design. A copy of the image you traced will be left on the bottom paper. The sharper the tool you are using to trace the design, the clearer the traced image will be. You will, however, need to refine the traced image before you do the final inking. Do not use the commercial carbon paper sold in stationary stores. It is coated with a composition of ink and wax that cannot be removed from the drawing surface, and will smudge when handled. Be sure to erase all the graphite left from the tracing. The graphite particles will muddy the paint. Large particles of graphite that are left behind will "write," or streak the paper if moved by the paint brush.

I've picked up a couple of tracing paper tricks over the years. You can simplify working with repetitious border designs by drawing the design once with a delineated border. Then place the area to be repeated under the master sheet, trace the design area, move it along to where it is to be repeated, and so on until the design is complete. When working with a symmetrical design, first draw the lines indicating where the artwork will sit. Fold the paper in half, making sure all four corners line up perfectly. Draw half of the design, up to the fold mark, then flip the sheet over and trace the design from the underside onto the top sheet. Voilà! You have a symmetrical design in a fraction of the time it would take to draw the whole design freehand. Every so often, after I've drawn the final lines in black marker, I decide to change an element in the pattern. Rather than draw the whole design over again, I cut out the piece to be changed with a sharp knife, tape

Figure 5–2

Figure 5–3

a new piece of tracing paper over the area, and draw in the new element. I use cellophane tape because it is transparent and allows you to see the lines on the master sheet. If you intend to reuse the design or elements of the design on future projects, lay a blank sheet of tracing paper over the master drawing and trace the image underneath. The master sheet will be preserved intact and clean for future use. There will be no confusion as to what ink lines were from earlier traceoffs and which were the ink lines just produced. The cover sheet also protects the master sheet from being cut by the pen point. Repeated use of a pen point on the same line will eventually weaken the tracing paper and cut right through, causing ink lines on the drawing sheet.

Tape the graphite-backed design to the paper on which the design will be completed, securing it with at least two tabs of tape on every side. Trace the design by going over the marker lines with a fine-point pen. Don't press too hard or the pen will tear through the tracing paper, or the pen will leave indentations in the paper surface. I like to use a blue or red pen to trace over the marker or pencil lines because I can see which lines still need to be traced. Remove the tracing paper and file it away for future reference. Use a pencil to tighten up the shaky or misplaced lines. Go over the pencil lines with a technical pen and black ink. Clean off the pencil marks with an eraser and color in the design.

Preparing the Paper

Paper of less than 140-pound strength must be stretched to minimize buckling from the application of watercolors. Securely anchor the paper to a drawing board with gummed packing tape. Do not use masking tape because it will pull off the board when the paper shrinks. Do not use thumbtacks because they hold the paper in specific spots; the paper will stretch in these spots and shrink in others and you will be left with a paper with warped edges. Wet the paper evenly from top to bottom and side to side with a clean, damp sponge. Let the paper dry thoroughly before you remove it from the drawing board. Cut the taped edges off the paper and begin your work.

Use a four- or five-ply 100 percent cotton paper. It is almost boardlike in weight, and reduces the amount of warping. You may need to use one- or two-ply paper when working on oversized pieces because the largest sheet of heavier ply paper is 30 by 40 inches. Do your writing first, design second, watercolor last. To iron out the wrinkles after finishing, flip the piece over onto a clean, even surface, wet the back evenly with a damp sponge, place a clean, smooth board on top of it, making sure all the edges are completely covered, and weigh the piece down with an evenly distributed weight. Let the piece dry overnight before removing the weight.

Art is an eloquent language in itself, composed of color, tech-

nique, and self-expression. Self-expression is what makes artists use different color combinations, concepts, and approaches. Self-expression is not a conscious effort . . . it just happens.

Three Rules in Painting

1. One hue looks different when surrounded by or placed next to different colors.
2. Colors affect each other by reflecting hues that surround them. Natural and artificial light create different effects in all colors. The amount of reflection depends on the surface of the object on which the color is painted. A glossy or shiny surface reflects more light, a matte or dull surface reflects less light, even if they are both the same color.
3. A knowledge of color and its effects is important to an artist, regardless of whether the painting is an abstract in which the colors must speak for themselves, or a study in realism.

Colors suggest certain emotions and ideas. White is a bright, positive color. Its luminosity suggests a light, airy, delicate feeling. It is the color associated with chastity, holiness, innocence, integrity, purity, surrender, and truth.

Black is a profound color associated with somber situations. It is the color of authority, death, gloom, grief, humility, loyalty, mourning, power, sadness, secrecy, serviceability, sorrow, terror, and evil.

Gray is a sedate color that makes an ideal background for most other colors, especially when it is tinged. It is a "colorless" color, suggesting humility and passive resignation. It is often associated with old age.

Brown is the color of action, autumn, earthiness, fellowship, fertility, masculinity, maturity, sports, physical strength, virility and warmth.

Red and orange are the colors of anger, belligerence, blood, courage, danger, defiance, dominance, excitement, fever, fulfillment, fury, human emotion, love, passion, sacrifice, slaughter, strength, triumph, valor, victory, inner warmth, vegetable growth, and violence. The color red has a great power of attraction. It is positive and exciting and aggressive. Orange is a vivacious, positive color, full of life and energy.

Pink is the color of dawn, flesh, joy, and intimacy.

Yellow is the brightest but least popular of all colors. Yellow is associated with divine beauty, cheerfulness, confidence, distinction, enlightment, esteem, excellence, fire, gaiety, gold, intelligence, knowledge, liveliness, playfulness, radiance, splendor, understanding. It is also the color of sickness, disease, indecency, envy, cowardice, jealousy, deceit, and treachery.

Green is the most peaceful of all the colors. It is often associated with religion because of the feeling of passivity it conveys. Green is the color of human beauty, contemplation, contentment, envy, eternal life, faith, friendship, fruitfulness, health, hope, immortality, joy, leisure, and vegetation. It is the color of spring, freshness, rebirth, peace, and serenity. Green is used to suggest jealousy and fear.

Blue is cool and serene, with intellectual appeal. It is an aristocratic color, used to convey a feeling of cold, demons, faith, fidelity, honor, immaterality, immortality, intangibility, introversion, mourning, nothingness, passivity, power, sadness, shadow, sincerity, spirituality, tenderness, terror, and truth.

Violet is a cool, melancholy color suggesting affliction, resignation, and old age. It is the color of chaos, death, dedication, dignity, dominance, enchantment, impressiveness, divine love, catastrophe, menace, oppression, penitence, piety, solitude, and superstition. The color violet is often used in religious paintings.

Purple is a stately, pompous color with a soothing influence. It is the color of affliction, frugality, impressiveness, melancholia, royalty, rank, and authority.

Silver is the color of joy and wisdom, while gold betokens sunshine and wealth.

Use the proper color in the proper situation. Use complementary colors to give depth to the art, but don't overuse the complement, or the main color will lose its freshness and become muddy.

ADDING COLOR

Tempera, designer colors, watercolors, and some inks are suitable for decorating calligraphic documents. These paints, if applied lightly and properly, will not crack or blister. Tempera, designer colors, and gouache are the best grade of opaque watercolors. They are heavy and stiff and best used on a board. When one color of tempera is painted over another, it covers and replaces it. With opaque watercolors, you can start with any value and work up to a lighter color or down to a darker color. Dark, transparent watercolors can be combined effectively with light, opaque watercolors. Acrylic paints can be used in the same manner as opaque watercolors, but they are insoluble when dry.

Washed and transparent watercolors are applied in successive layers of transparent color. The color is watered down or intensified by layering washes. There are flat washes, graded washes, and superimposed washes. To apply a *flat wash*, load the brush with the color you want at the value you want. Start at the top of the area to be covered. With quick, even strokes, float the brush across the paper. Hold the brush flat so most of the hairs touch the paper. The pool of color is brought forward with the heel of the brush. When the end of a stroke

is reached, bring the wash down. Without lifting the brush, start back across the paper in the opposite direction, allowing it to overlap the previous stroke a little. Continue over the area to be colored until it is finished. Before the brush loses its color and the previous stroke dries, dip the brush back into the palette and then continue the previous stroke. If a pool of color is left at the end of the area to be colored, pick up the wash with the tip of the brush. If it is left to dry on the page, the wash will leave a darker stain on the paper.

Superimposed washes build up the tones: the darker the color, the darker the tone. First apply a flat wash to the paper and let it dry. Paint lightly over it with the same color—the area painted with a second coat will be darker in color. Be careful when applying washes of a different color. Complement colors applied one on top of the other can become muddy.

Graded washes range from dark to light. Load the brush with a dark tone and apply it to the paper. Dip the brush point into clean water every stroke or two, diluting as you proceed downward. Hard edges can be softened easily with a clean, damp brush point. Rinse the brush out in clean, warm water. Drag the tip across the edge of the wash, rubbing the edge a little with the brush point.

I use the British technique of watercolor, building up washes of color until I reach the desired intensity. I add the complement to the color I am using if I want to create muted tones. I might use a muted green and paint muted red over it in an area where I want a shadow and depth. I might mix a little blue or orange with the green and add intensity to the edge by outlining it with a stronger color. The dark line pushes the lighter colors forward, making the piece seem brighter, richer, and more defined.

Sometimes white lines and gold dots are added for emphasis. The white streak or line helps harmonize and soften, or brighten the colors if they are too dark. Gold dots are a traditional decoration. They are usually outlined or furred with black.

Black and white are the two extremes between which all colors fall. White is the combination of all the colors of the rainbow. Black is the total absence of color. There are many shades of gray between the two extremes.

Colors are judged for their brilliance. The brilliance, or value, of a color is judged by its relationship to black or white: a color that is close to white has a high value; a color closer to black has a low value. The brilliance of a color is affected by its surroundings: a dark color on a light background and light color on a dark background offer a striking contrast.

Color Theory

There are primary colors that cannot be mixed from existing colors—red, yellow, and blue. All other hues are mixed from these and

are called secondary colors. Red and yellow produce orange; yellow and blue produce green; blue and red produce violet. Two secondary colors mixed together produce a tertiary color. Tertiary colors, which have an earthy brown tone, contain two parts: one primary color and one part each of two other colors. Violet and green contain red-blue and yellow-blue; orange and green contain red-yellow and yellow-blue; violet and orange contain red-blue and red-yellow.

A color wheel was devised to help the artist quickly find a color's complementary secondary and tertiary color. You can paint your own or buy a book that has one. You can purchase a "color computer" from M. Grumbacher, Inc., 460 West 34th Street, New York, NY 10001. On one side is a painted wheel with punchouts to show the color with red, white, black, blue, or yellow added. On the flip side are punchouts showing the analogous harmonies—colors that work well in combination with the key color—complementary colors, split complementary colors (colors immediately to the left or right of the complementary color), and triadic colors (those that are two colors to the right and left of the complementary color). It is an extremely useful tool for the artist (see Fig. 5–4).

Pantone (Pantone, Inc., 55 Knickerbocker Rd., Moonachie, NJ 07076) is a color-matching system with approximately 501 solid colors, shades, and tints of colors, colors with white, black, and their complements. I show it to clients who have difficulty describing the colors they want.

Complementary colors positioned close together interact, making the other colors look brighter. Opposite colors bring out each color's individual character to maximum effectiveness. Equal portions of two complementary colors mixed together will produce a muddy, neutral gray color. A complementary color mixed into another complementary color neutralizes or tones down the color. The more of a complement any color you mix into another, the more muted it becomes. This is because of the harmony that exists with the colors it is placed with that allows the color's hues to change subtly without being disrupted.

Colors that contain large proportions of red, yellow, and orange are called *warm colors*. They bring to mind a feeling of fire and heat. Colors with proportionately more blue and green are considered *cool colors*. Blue makes us think of ice and snow, green makes us think of the freshness of grass. Hues can be made warmer by adding red, orange, or yellow, or cooled by adding white, blue, or green. Warm colors come forward in a painting, cool colors recede.

Understanding warm and cool helps you understand *spatial relationships:* a color's visual effect in creating a feeling of depth. Cool colors look brighter on a warm background. Warm colors look brighter on a cool background. An area of design on a warm background can be made to appear brighter by outlining it with a cool color. Different combinations of colors create different effects. In watercolor paint-

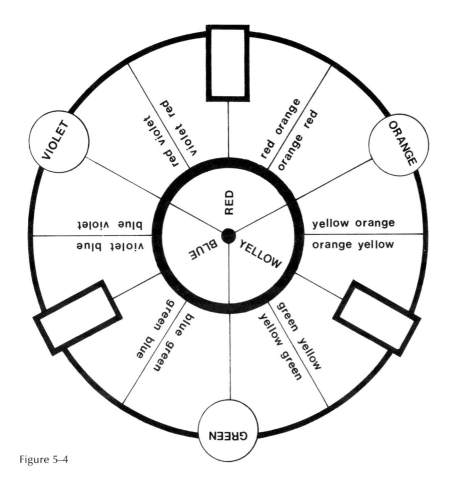

Figure 5–4

ings, the brightest spots of the designs should be painted first. Rings of the desired colors are painted and blended before the color dries. Then darker colors are added around the brilliant spots. Note that the highlight of colors is not always white, nor is it always centered. The highlight of white is yellow. The highlight of orange is pale green. The highlight of red is pale blue. The highlight of blue is light green. Both a color wheel and color theory tell you which colors highlight which colors.

The effects of sunlight and artificial light on color must be considered when coloring a painting. The color of sunlight changes with the weather and the time of day. A cloudy day casts gray tones. The morning sun casts a cool yellow, the noontime sun casts a warmer yellow, and the afternoon sun takes on a reddish glow. The setting sun casts an orange glow on everything. Shadows change every few hours.

Artificial light has both good and bad aspects. Because it is effective only for short distances, it is best used for work done directly under the lamp. Keep in mind that different lights cast different colors. Most artificial lights cast stronger shadows than natural sunlight.

Shadows from an artificial light stay in the same position unless the lamp itself is moved.

Paintings should be finished in the same light in which they are started. The best light, considering the factors of evenness of color and the time element involved, is a combination of natural, fluorescent, and incandescent lights. Switching from daylight to fluorescent to incandescent light produces a mess of different-toned patches of colors. Colors that look right at the time they are put on the paper will actually be lighter or darker, or of different values, than what you intended.

PART IV

DISPLAYING YOUR WORK

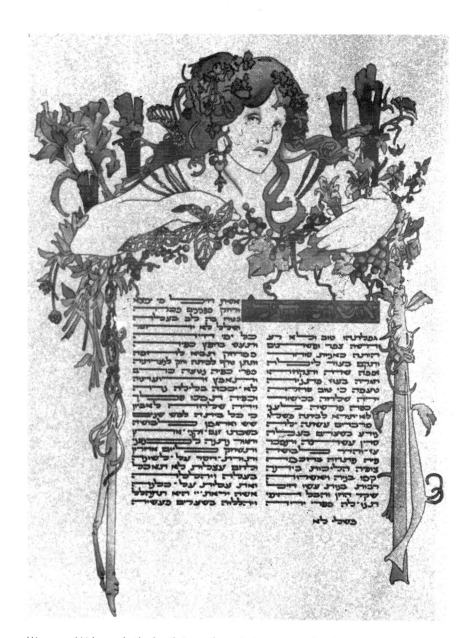

Woman of Valor, *esheth chayil*. From the artist's private collection.

CHAPTER 6

LAYOUT AND DESIGN

THE LAYOUT

The various elements of the overall design must be arranged in an orderly and attractive fashion before being committed to the final paper. This is known as the layout of the design. The text or body of the page is placed in a fashion that is pleasing to the eye, in conjunction with any titles, initial capital letters, indented caps, drawn or flourished letters, and border design. Black and white and colored areas need to be balanced. All of this is done first in a sketch, showing the placement of the lettering, the larger words, and the body of the text (Fig. 6–1). The final layout is a comprehensive sketch, a step closer to the finished piece than the rough. Markers or colored pencils can be used to indicate colors. It is at this point, after the layout is made, that any decorated elements, initial letters, or art borders are planned and executed on tracing paper.

In finalizing a layout, a number of factors must be considered. For example, a formal, symmetrical layout should be chosen for wedding invitations, wedding contracts, Torah portions, and so forth. An informal, asymmetrical design can be used for monograms, poems, and phrases, where a lively feeling can be conveyed through the arrangement and placement of letters on the page (see Fig. 6–2).

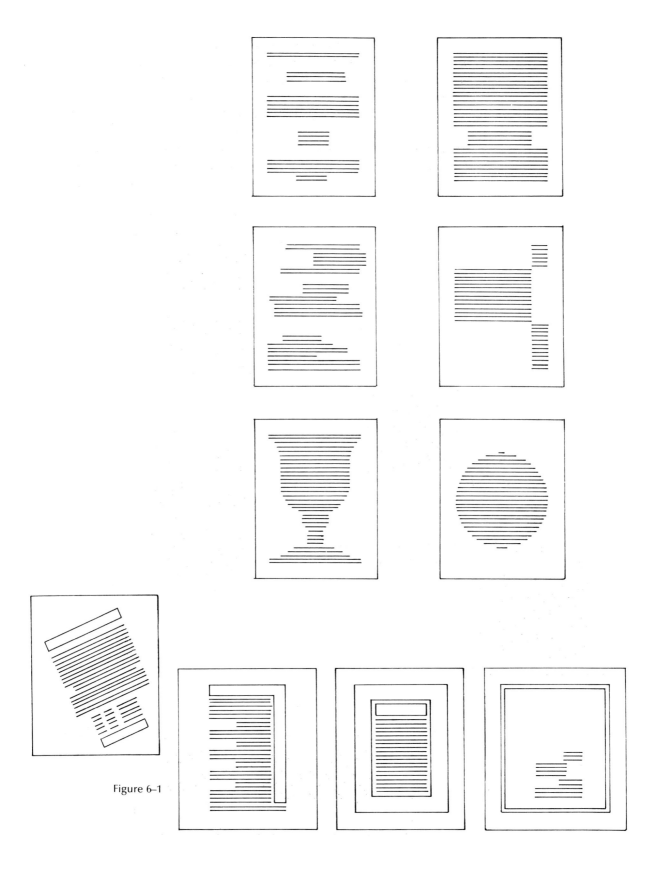

Figure 6–1

The weight and texture of the drawn letters, and the weight and texture of the text, are the primary concern of the scribe when designing the page. The scribe must achieve a compatible relationship between the look of the written word and the drawn (larger) word on the page. Titles, which are often drawn, should be no more than one-third the height of the text.

The entire first word of a heading can be made into a design at the beginning of the text, or a large, initial letter can hold the adjoining letters within it.

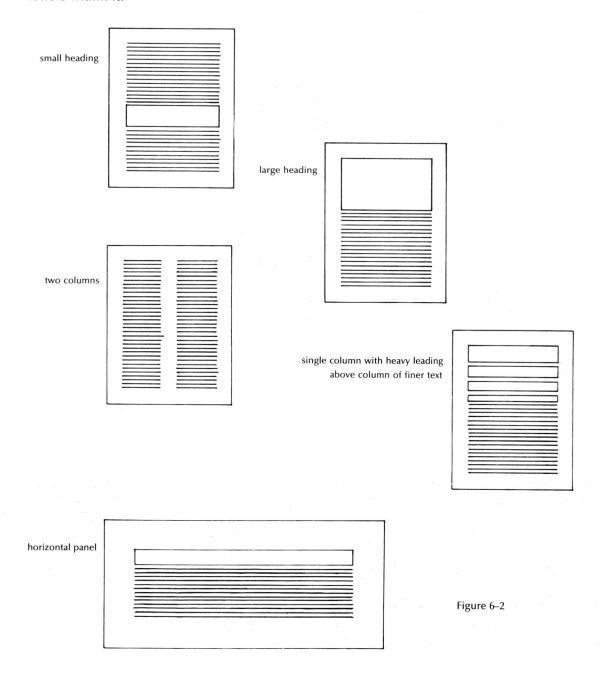

small heading

large heading

two columns

single column with heavy leading
above column of finer text

horizontal panel

Figure 6–2

LAYING OUT THE TEXT

The layout of the text should not be left to chance, but should be calculated before the work is committed to the final paper, even if that means writing the whole piece out in full on a piece of scrap paper. There is no hit-and-miss method for calculating words, but in time practice will make you a good guesser.

First, choose a quotation that is appropriate for your purpose, then jot it down to determine what arrangement of words best brings out the meaning. The size of the passage should be determined by its purpose, tradition, and place in the overall design. To avoid losing your place in the text from which you are copying, place a clean colored sheet of paper directly under the line you are working on. This will prevent your eyes from jumping to the line below. Copy two or three lines to begin with, so that you have an idea of the spacing of the nib and line size.

To calculate the number of words per line, follow this method. Use the medium Osmiroid nib in a work designed for 3 mm spacing. This spacing averages one word to the inch. Leave 5 mm spaces between lines. To calculate the number of sentences per page, calculate the width of the writing size and divide it by the number of words to be written. For example, 6 inches and eighteen words means three lines of writing.

Once you have calculated the size of the quotation, write out the longest line to gauge the length. Then center the text on your paper. If you have an uneven right margin, you must adjust the horizontal length accordingly to make the piece appear centered. Finally, calculate the vertical length. It is important that you calculate the number of words first and then measure the page. Do not work backward, fitting the passage to the page (see Fig. 6–3).

Figure 6–3

DECORATIVE ELEMENTS

When you are laying out the text, you must take into account the size of any initial letters, drawn letters, or other decorative elements that will be added after the text is written (see Fig. 6–4).

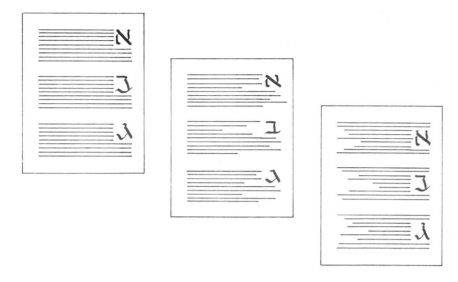

Figure 6–4

Initial letters can be fully set in the text. Traditionally, the line of written text writing starts from the top rather than the bottom of the initial, which is followed by one or two words in capitals. Enlarged lines of color are often used to focus interest on the beginning of the text. Black is a very strong color. The enlarged letter must be balanced in weight. Weight describes the width of the strokes forming the letter parts. Careful consideration must be given to the weight of the letter on the page and the paper around it. A letter that is weighted too heavy will appear like a blot on the page. The importance of the relationship of size to color cannot be overlooked.

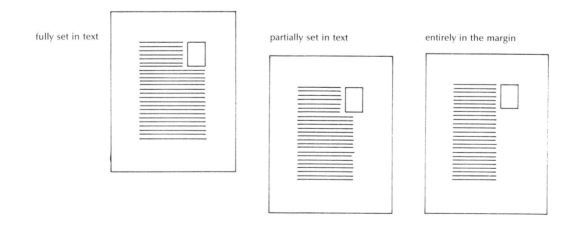

fully set in text partially set in text entirely in the margin

Use the following method to calculate the displacement area of an initial letter. First, decide on the size of your initial letter—2 inches wide and 3 lines high, for example. If there is an average of one word to an inch, the initial letter will displace the space of six words (3 lines x 2 inches). You can also say that it will add six word spaces to the total length of the text.

If your text is, say, thirty words long, with six words to each line, you will need five lines without the initial letter. With it, you will need six lines (30 + 6 = 36 word spaces divided by six words per line).

Once the calculations are done, rule up the final page of writing in accordance with the model, making sure the height of the letters and the width of the strokes are in keeping with the sample.

MARGINS AND BORDER

Calculate the size of the margins and determine whether the piece will fit a regular sheet of paper or require an oversize sheet. (It is a good idea to keep a couple of oversize sheets on hand in case they are needed in a hurry.)

When cutting the final sheet of paper to ready it for delivery or matting, make sure that the top and side margins are equal and that the bottom margin is at least ½ inch larger than the other borders, to allow room for the date and artist's signature.

For example, if the writing space measures 8 x 10", leave a ½-inch border on all sides between the text and the artwork. The border will measure 1½ inches on all sides. You will need a 16- x 18-inch sheet (see Figs. 6–5, 6–6, 6–7, and 6–8).

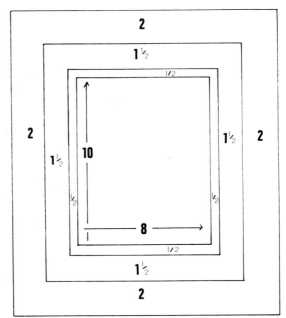

Figure 6–5

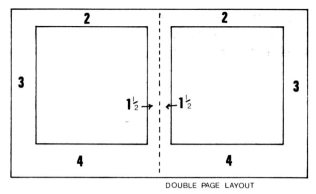

Figure 6–6

DOUBLE PAGE LAYOUT

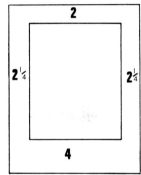

Figure 6–7

SINGLE PAGE

Figure 6–8

CHAPTER 7

DESIGNING FOR REPRODUCTION

Calligraphers are often approached to design artwork such as invitations or greeting cards that are intended for reproduction. The calligrapher who is not familiar with the basics of reproduction may render a beautiful art piece that reproduces poorly. When artwork and lettering are prepared for reproduction, the emphasis shifts from the final look of the original art to the final look of the printed copy. Many times the final art must be retouched to give it a clean, slick look, free of ragged ink lines and dirt. It is the calligrapher's responsibility to be informed about the printing process and to speak to the printer about any specifications on a particular job.

Hand lettering for reproduction requires extra effort in the layout and lettering of the page to be reproduced. Letters must be clean, well formed, and evenly spaced. It is often quicker and more convenient to use instant type letters, which have treated backs and come on a clear plastic sheet. These letters can be burnished onto the final paper with a pen, pencil, or burnisher. However, these letters can crack, or fall off the transfer sheet or the sheet to which they are being transferred. When this instant type sits on a shelf too long, the tacky substance on the back of the letters has a tendency to fry. If this occurs, moisten a clean cotton cloth with rubber cement thinner and gently rub the back of the transfer sheet, being careful not to remove the letters.

Instant type is marketed by a number of manufacturers, including Letraset, Formatt, Transfertype, Prestype, and B. Arbit Books. Most companies offer instant type in a variety of different languages, but the largest and most varied selections are usually the Roman alphabet. The selection of Hebrew instant type is poor. Instant type manufacturers also produce design motifs that can be arranged to complement the lettering.

Artwork meant to be reproduced for invitations in a single color should be prepared in black ink on white paper. The color that the design will be printed in is selected from the printer's color swatch chart. Coloring the elements of the design can help make the design more legible, particularly if the elements are intricately arranged. Most people opt for one color—printing with more than one color is expensive—but color can be suggested by the careful use of black and white design elements (letters filled in completely with black, and letters outlined in black). Depth and variety in letters and design can be achieved by *stippling* (Fig. 7–1). Stipple is the effect created by tapping black ink dots onto the white paper—the greater the density of the dots, the grayer the stippled area becomes. Shading sheets, or dot screens, give the same effect as stippling. These sheets are covered with dots: the greater the number of dots per square inch, the grayer

Figure 7–1

the piece; the fewer the number of dots, the lighter the piece. The sheets have a tacky back that when burnished, adheres to the sheet on which the design is being worked. Dot screens come in single sheets ranging from ten percent to ninety percent (100 percent is solid black). Single sheets are available that range across the sheet from twenty percent to seventy percent, creating a dimensional quality to the design. Shading sheets are available from the manufacturers of instant type sheets.

The design is sketched lightly in pencil on the final sheet. The shading sheet is placed over the design, and the design or letter is cut out from the shading sheet with a very sharp X-acto blade. After checking that the design is completely cut from the shading sheet and not attached in any way, the shading sheet is lifted from the board, leaving the letter or design on the page (Fig. 7–2).

The calligrapher must have a basic understanding of the printing process to produce an effective design that will look as good on the printed piece as it does in the original (see Fig. 7–3). A rule of thumb to follow when preparing art to be printed is to draw the art larger than the required final size, preferably twice as large as the final printed size ("twice up"), and a minimum of one and a half the final size needed ("one-half up"). Inevitably, there are imperfections in the original art that are noticeable in the printed piece—uneven lines, white spots in the black ink, or spots where the pen skipped the ink line. When the art is reduced, the black ink lines pull closer together, eliminating white holes in the ink, thus minimizing the faults. Artwork that is "blown up," that is, enlarged in size, maximizes and exaggerates the faults in the artwork: crooked lines and ragged edges become more obvious; gaps in the ink line increase. If the only solution is to enlarge the piece before making the print, a "stat" (photostat) must be made, either from a direct positive (the design as it is given to the printer) or from a negative. This can also be done "same size" as the artwork (not changing the size at all, just reversing the emphasis of the page), or the artwork can be reduced. The letters enlarged on a stat must be "cleaned up" with white paint and black ink, to compensate for the exaggerated faults in the line. Blowing up artwork can be costly because the process must be done slowly, one-half up at a time. Reduction is comparatively simple, one shot reduced to the size requested.

Fine lines will all but disappear when they are reduced, because the width of the ink line decreases proportionately. To prevent ink lines from disappearing completely, they should be drawn twice as thick as you think necessary. A stat reduced to the required size will give you an accurate picture of how the ink lines hold up in the smaller dimensions.

Making a photocopy of the design to be reproduced is useful in checking for errors in the lines of the design. The copy shows what

Figure 7–2

Figure 7–3

Designing For Reproduction **133**

lines need to be corrected or eliminated. When you look directly at the artwork, you are seeing it from a variety of angles, but the camera sees the artwork from one angle—straight on. Photocopying mimics the camera, and indicates which areas need adjusting, more ink, or touchup with white paint. (This method comes in handy when checking paste-ups for line alignment or dirty edges that will be picked up by the camera.)

It is very important that a border of at least 4 inches be left on all four sides of artwork meant for reproduction because it will be handled by many people. These extensive borders serve as "gripper edges." In other words, they keep the gripping hand away from the artwork. Artwork done on Bristol board must be backed with a sheet of illustration board to help it withstand the handling and abuse it will take. The final design is drawn on tracing paper. Once you have reached an acceptable presentation of the design, trace it onto a clean sheet of tracing paper, using a fine- or ultrafine-point black magic marker. Tape the design to a sheet of illustration of Bristol board. Slip the carbon-backed paper under the area to be traced and trace the design with a BIC pen. Its rounded point is perfect for tracing designs. Remove the carbon-backed paper from under the design. Check to make sure that all the elements of the design have been traced before completely removing the traced design from the drawing paper. The carbon paper can be thrown out or saved to be used again. Do not cut the art board to final size until after the design has been transferred and inked in.

The design is inked in with the aid of mechanical tools, compass, French curves, and a steel-edged ruler. Ideally, the finished work should not need retouching at all. Shaky ink lines can be straightened where necessary with pen and ink, #00 brush and ink, or white retouching paint. A duo flap of brown wrapping paper on top of tracing paper should be cut to the size of the outer dimensions of the board and hinged over the plate to prevent the artwork from being soiled. The brown paper is sturdy and will withstand the effects of coffee cup rings and minor liquid spills. The tracing paper overlay prevents the artwork from being soiled when it is handled. Instructions for the printer should be written lightly on the overlay. Such instructions include the direction and amount of artwork, and whether it is to be printed in matte (dull) or glossy (shiny) finish. The direction in which a piece is to be reduced is determined by the measurements of the area in which the design is to be reproduced. For example, if the design is 6" x 10" and is to be printed on a 5" x 3½" surface, half of 6" x 10" is 3" x 5", which is too wide for the 3½-inch width. Indicate on the tracing paper that the piece is to be reduced in height to 3 inches (for argument's sake), leaving a ¼-inch border on either side.

Draw a straight line at the top edge and another line at the bottom edge of the design. Draw an arrow top to bottom between the lines,

leaving empty space in the middle in which to write directions for the printer such as, "reduce to 3" BM (Between Marks) (see Fig. 7–4). Indicate the surface you want.

Sometimes when preparing artwork to be printed, it is necessary to paste together on a board several units of type, design, monograms, and lettering. The design units must be placed in position on illustration board, according to the prescribed layout. Retouching, corrections, and additions to the drawing can be done directly on the mechanical.

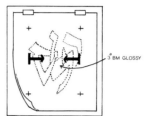

The elements of the design should be prepared on one- or two-ply paper. Before the units of design are cut loose from the paper, the sheet should be flipped over and the back coated with rubber cement. The rubber cement is left to dry. The units of design are then cut free from the large sheet with a sharp X-acto blade.

Coat the illustration board with rubber cement. Quickly position the elements and mount them in place while the adhesive is still wet. The flexibility of the wet adhesive allows for the repositioning of the elements if needed. One-coat rubber cement, which is applied only to one surface, is flexible even when it is dry. Elements can be moved relatively easily after they are applied to their boards. Two-coat rubber cement, which is applied to both surfaces, creates a stronger bond and must be removed with rubber cement thinner.

Apply the rubber cement first to the surface to be cut, second to the surface to be mounted. If both surfaces are allowed to dry the work can be removed, but only with great difficulty and the help of cement thinner.

Figure 7–4

Slip sheeting, the technique of separating two rubber cement-coated surfaces with a clean sheet of paper, is used to slowly adhere the coated surfaces to each other. It allows you to ease the surfaces together a bit at a time, making sure they are positioned and lie where they are supposed to. Once the work is positioned in place, slip the center sheet down, a bit at a time, attaching the paper to the board surface, until the whole piece is attached. Place a clean sheet on top of the adhered area and rub the heel of your hand over the area to make sure the paper sits in place, eliminating air bubbles.

Two-coat rubber cement should be diluted with thinner until it is runny. The thinner is applied from a dispenser equipped with a long, thin nose that allows you to poke it into small spots and direct the flow of the thinner where you want it to go. Thinner loosens dried rubber cement and allows you to pick up and move the units involved in the paste-up.

Remove the excess rubber cement with a "pick-up," a commercial rubbery eraser-type tool sold in art stores. It picks up any rubber cement peeking out from under the paper or left on the board. The rubber cement can also be removed by balling up the residue left on the paper and using it like a magnet to clean up the remaining rubber

cement. Move the pick-up gently near the cut paper edges so as not to
tear them. Paper edges that have turned gray from handling may be
touched up with retouch paint.

CHAPTER 8

PHOTOGRAPHING
YOUR WORK

Keeping photographic records of your fine artwork and calligraphic jobs is essential for building a good presentation portfolio. Regardless of whether or not you intend to pursue calligraphy as a vocation, you should keep a photographic record of your work, in case of theft or damage to the original art.

It is to your advantage to have the finest quality photographic reproductions of your work that you can get. Poorly exposed and out-of-focus snapshots of your artwork puts you at a disadvantage when you are trying to convince a prospective client to pay your professional fees. The client isn't interested in hearing, "The photo is not the best. The original really looks quite different."

There are three criteria used to judge the quality of photographic reproductions: sharpness of focus, correct exposure, and true color representation. I will discuss inexpensive procedures that will yield the best reproductions. You will need the following equipment:

1. Camera with adjustable aperture and focus

2. Light meter (if not built into the camera)

3. Gray card

4. Two photographic floodlights, rated at 3400 degrees, with twelve reflector hoods and stands

5. Photographic print or slide film

First, create a set-up (Fig. 8–1). The artwork can be taped or pinned to a wall or flat board. The camera should be placed on a tripod or some steady rest to prevent blurring from camera movement—the back of a chair or a stepladder. Try not to take the picture with a hand-held camera.

The camera lens must line up with the center of the artwork, so that the film is being held parallel to the art (Fig. 8–2). The image of the art on the print or slide will come out distorted or out of focus if the camera is held on an angle (high, low, or over to the side).

Prevent glare on the art by placing the floodlights apart so each is turned forty-five degrees to the artwork surface. Place the floodlights far enough away from the art to provide even light over the surface of the art. Place them slightly behind the lens of the camera, otherwise the lens will take in the glare from the lights.

Figure 8–1

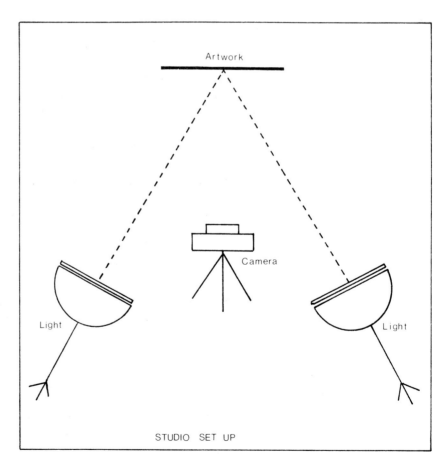

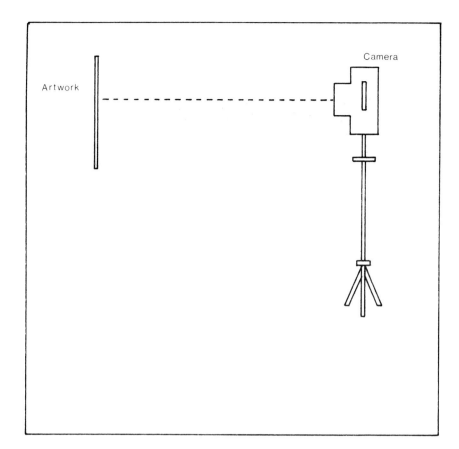

Figure 8–2

Most cameras equipped with manual focus provide more than adequate focal control. A camera fixed on a tripod prevents distortion from camera movement when the camera is set on slow shutter speeds, allowing for a smaller aperture and sharper picture. Avoid using wide-angle lenses. They cause straight lines to appear curved. Telephoto lenses are excellent for photographic straight-line work like calligraphy and for closeups of elements in the design and writing.

EXPOSURE

Many well-meaning amateurs "lose" the picture when determining the proper exposure. The built-in or hand-held light meter will give an incorrect setting almost every time when photographing calligraphy on white paper. Light metering units are designed to indicate the correct exposure settings for average indoor or outdoor scenery, including light, dark, and intermediate gray areas. The overwhelming whiteness of the page fools the metering system into giving an incorrect reading. The only way to guarantee the correct exposure all the time is to use a gray card, available at your local camera shop.

The gray card is tested with floodlight bulbs, sunlight, or room light. It is not tested with a flash. Set up the camera, lights, and artwork. Position the gray card directly in front of the artwork. Turn on the floodlights. Measure the light reflecting off the gray card. If your camera has a built-in light meter, meter the gray card just as you would meter the artwork if the card weren't there. (Be sure that the gray card fills the whole viewfinder area so that no other light is metered.) Adjust the camera for the correct exposure on the gray card. Remove the card and photograph the artwork. This procedure will give you the correct exposure every time.

If you are not using a gray card, or if you are using an electronic flash, the white paper will deceive the built-in light meter or electric flash. Compensate by "bracketing" or manually overriding the automatic or normal adjustment by two f-stops. The proper exposure can be determined only by testing some trial shots on your own equipment.

TRUE COLOR REPRODUCTION

Achieving true color in your prints depends on two main factors—the film brand and the processor. Several factors depend on the photographer. The film must match the type of light being used for illumination during the photographic session.

Color tone is measured by *color temperature*. Color photographic film is rated by color temperatures that indicate which type of light will reproduce true color images.

Incandescent light bulbs give off a warm tone, the light appearing as a yellow overcast. Indoor film must be used when incandescent light is the source of light. Indoor film has been color-corrected to compensate for the incandescent light's warm yellow tone. Electronic flash and sunlight give off a cold blue light. Pictures taken with a flash unit or in natural sun must use an outdoor film. Outdoor film has been corrected to compensate for the blue overcast of the light. The salesclerk at the photography store can give you the proper film for your needs.

I use Kodak Kodachrome® Type A slide film, ASA 400, which is rated an indoor film (3400 degrees K). With it I use a 35 mm SLR (single lens reflex) camera. This combination of film and lighting is a controlled match. Unlike a flash, the light can be turned on before the shutter to set the exposure. I use the built-in light meter and a gray card held in front of the subject to determine the exposure. Correct exposure and color temperature give me perfect slides every time.

Kodacolor® or regular Kodachrome® are good outdoor films. To use print film directly, use Kodacolor print film with the same procedure as for slides. Ask the salesperson at the camera store for FOTO®

flood bulbs. They work best with the type of print or slide film you want to use.

I use both print and slide film. Slides offer you a positive from which to make good prints. They are cheaper, can be stored in slide packages or projector trays, and finally are excellent picture material for lectures and demonstrations. Bear this caveat in mind: inevitably, you will receive requests to lend photographs or be asked to mail slides. After a few incidents of lending slides and prints and not getting them back, I have learned to ask for a $20 deposit on every borrowed print to cover the inconvenience of redoing prints if the need arises. I do not mail slides because I do not want unauthorized prints to be reproduced. If the borrower insists on slides, deface them with a scratch, thus discouraging pirated prints. Have a prospective client sign a receipt for the photographic material. Specify the terms of lending on the receipt and list the borrower's name, address, and phone number, plus two references to make sure the information is bona fide.

CHAPTER 9

MATTING AND FRAMING

THE MAT

Artwork drawn or painted on paper that doesn't have sufficient body to bear up over time can be made more permanent by being mounted on a rigid support. To be displayed at their best, watercolors and drawings need a mat. Matboard can be bought from an art store, and it comes in a variety of colors and surfaces. One side is usually colored or textured and the other side is usually white. It measures about ⅛-inch thick.

People often mat artwork for the wrong reasons, if at all—either to increase the size of the picture or to add color to their walls. The main reason for matting any piece of art is to protect it and set it apart from its surroundings. Pastel paintings, watercolors, and chalk, ink, and pencil drawings are often placed in frames without being matted. This is a mistake. The thickness of the mat holds the picture away from the glass, preventing condensation from forming under the glass and ruining the artwork. Moisture build-up wets the artwork. When the art is unmatted and held by the backboard against the glass, the picture will transfer to the glass in about three to five years. When the picture is removed from the frame, there will be two faded images—one on the paper, the second on the glass.

The mat, like the frame, can make or break the picture. It must be properly cut and placed tastefully around the artwork. The inner edge of the mat should be a minimum of ¼ inch away from the artwork if the mat is white, cream, or eggshell color. A colored mat requires a minimum of a ½-inch border. The average mat should measure 3 inches wide at the top and sides and 3½ to 4 inches on the bottom. The dimensions of the mat should be increased in proportion to the size of the artwork. The larger the art, the smaller the mat; the smaller the art, the larger the mat. Mats are customarily cut wider on the bottom: a picture matted equally on four sides appears to have less weight at the bottom edge and looks as if it is falling down in the frame.

The rule of thumb in choosing a mat color is to select a shade halfway between the lightest and darkest colors in the artwork. This does not preclude a lighter or darker mat. The choice of color is purely individual and often reflects the colors of the room in which it will be hung. Decorators suggest accenting a secondary color in the picture that complements the decor of the room. If the overall color of the picture is blue, but contains oranges and browns, and the room is wood-toned, a soft or neutral orange-tint mat will give the picture sparkle. Done properly, a quality mat will provide a resting area for the eye, with the color of the mat helping to make the art stand out, or serving as a border against a busy background. Ideally, the mat should highlight one color in the picture to prevent distraction.

Double matting can be used to soften one color in the art that might be overpowering. Fabric and natural-fiber mats add texture, softness, and mood to the look of the picture. Textures diffuse light and optically soften a color while keeping the same color hue. A mat should complement the mood of the artwork. When choosing colors and textures, take into account the surroundings in which the art will be placed.

In general, bear these guidelines in mind when choosing a color:

1. The bold quality of oils is complemented by a bold colored mat.

2. Watercolors with a lot of white showing through are enhanced by a richly colored mat.

3. The softness of pastel colors can be maintained by using a mat in a tint of one of the colors in the picture.

MATTING AND FRAMING

1. Precut mats are available in art stores, but they only come in standard sizes. If you buy board, make sure it is big enough to cover the art generously. Measure the dimensions of the

art as you want to see it, then mark the measurements on the back of the board with pencil. Be sure to measure your lines carefully and guide the pencil lines with a ruler. For example, if the artwork measures 11″ x 14″ leave a ½-inch border all around, thus giving your art the dimensions 12″ x 15″. Measure 3″, 3″, 3″, and 4″ mat borders, giving a mat size of 18″ x 22″.

2. Cut the outer measurements of the mat and then cut out the window. Use a sharp X-acto knife guided with a steel-edged ruler. Follow your pencil lines carefully, making sure not to overstep the lines on the inner window. To cut mat with the X-acto, slowly and gently ease the blade in. Go over your line three or four times, each time pushing a little farther into the mat until the blade cuts cleanly through. Repeat on all sides. Smooth the inside of the window edges with fine sandpaper.

3. Hinge the artwork to the backboard—use one long hinge or two shorter hinges. For a single hinge, cut a strip of rice paper the length of the top edge of the picture and one quarter as wide as the picture is long. For double hinges, cut two strips of about an inch or two, depending on the width of the picture, and one quarter as wide as it is long. Fold hinges in half and apply the paste lightly and evenly to one outside surface. Attach to the back side of the artwork at the top edge.

4. Measure where to attach the art to the backboard by laying the mat on the board and marking the inside corners of the window with a pencil.

Mark corners lightly with pencil.

5. Apply the paste to the other side of the hinge and attach the hinge to the backing board. If you don't wish to use paste, Talas (213 W. 35th Street, New York, NY 10001) sells gummed linen, museum paper tape, and pretreated starch that can also be used to hold the art on the backboard or mat.

6. Never cut the art to fit the mat.

Wheat Starch Paste

1. Mix ¼ pound wheat starch with 1½ cups of water. Put the mixture in a covered jar for three weeks. Pour off the water that has risen to the top.

2. In the top of a double boiler, mix one part soaked starch with five parts tap water (one cup finished paste will mat around twelve average-sized prints). Heat until warm to the touch, 150°–225° Cook, stirring constantly, for forty-five to fifty-five minutes over a low heat, until the paste is the consistency of cake batter.

3. Add ½ teaspoon preserving solution during the last five minutes of cooking. The preserving solution is made from ¼ teaspoon boric acid dissolved in one cup of water. Stir the solution well.

4. Transfer the paste to a clean, airtight container. Keep the paste for no more than three and a half weeks.

5. Before using, whip the paste until it is the consistency of sour cream.

The Frame

Finding the right frame can be a chore. An original painting worth a considerable amount of money can be an eyesore if it is poorly framed, or a source of enjoyment if it is properly framed. Decide on the visual effect you want to create with your artwork. A stylized frame with an exaggerated liner or mat creates an exciting look. Calligraphic documents look elegant in ornate gold-tone frames with narrow liners or mats.

Consider where the frame will hang, and its width, tone, and degree of ornamentation. Let the technique in the artwork help you determine the best frame choice. Oil paintings look best in large

frames, and are never glassed in because of their raised texture and the consistency of the medium. Watercolors adapt well to most frame styles, from traditional, heavily-carved frames to sleek, modern, silver or gold sectional frames. Be careful not to overpower the artwork with a frame that is too heavy.

Pictures rendered in pencil, ink, watercolor, pastel, collage, and the like must be protected from dust and careless handling by a piece of glass. When shopping for glass, compare how the artwork looks under single-sheet glass and plexiglass. Non-glare glass costs slightly more than the usual single-sheet glass used for framing. Distortion and color variation can affect a picture when non-glare glass is held away from the picture by a mat. Plexiglass is considerably lighter than single-sheet and non-glare glass, and it scratches easily and tends to collect dust on the surface.

Bear these things in mind when you are framing your work:

1. Handle the picture with care. Oil, moisture, and dirt from your skin can damage the paper surface.

2. Do not trim the picture to fit the frame. The frame should fit the artwork, not vice versa.

3. For maximum protection, the backing and the mat should be acid-free, 100 percent rag content to minimize moisture damage. The artwork should be fixed to the backing with rice paper hinges and rice or wheat paste (available at art stores or framers). With the exception of artists' white tape, synthetic glues and adhesive tapes can ruin the paper. Hinge only one side of the artwork to allow for expansion and shrinking of the paper. Do not adhere the artwork directly to the back of the mat. Horizontal art should be hinged on the top; vertical art should be hinged on the side.

4. Do not hang the artwork in direct sunlight or it will fade and the paper will yellow. The art and paper will also deteriorate if exposed to extremely dry heat or damp conditions.

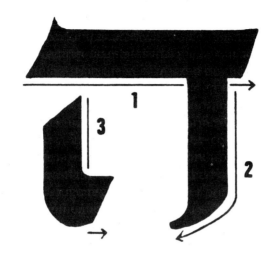

PART V

MARKETING YOUR PRODUCT

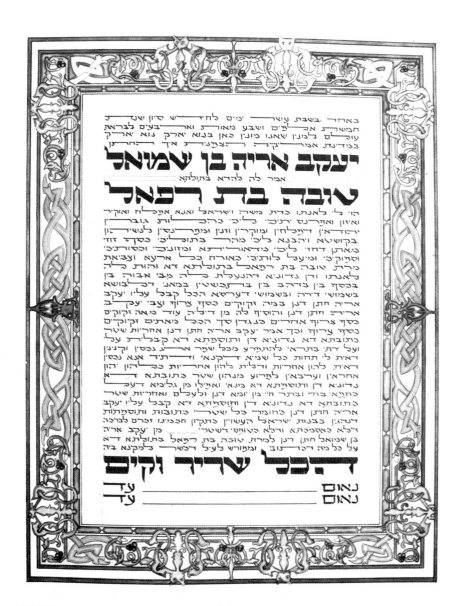

Wedding contract. Private commission of the artist.

CHAPTER 10

THE PROFESSIONAL
CALLIGRAPHER

When dealing with clients and setting prices, it is important to bear in mind a number of things.

It is the client's responsibility to come to the artist's studio for the initial consultation and to pick up the finished artwork. Your time is valuable, and you need not go to the client unless you are going to be compensated for your travel time and expenses.

Be courteous and polite to your clients. Dress nicely when you meet them. Make all your notes in a clean binder and use a gold-colored pen. Gold is the color of success and you want to convince your clients that you are successful. Serve refreshments to your clients. Be considerate, and aware of the fact that you need them just as much as they need you.

Show them your portfolio, which should contain photographs, printed samples, some original work, and other pertinent material. Keep an up-to-date portfolio of your commissioned works. Refer to jobs completed for other clients, even though they were done for your mother, Aunt Sadie, or Uncle Moishe. (You don't need to tell prospective clients that. Let them assume it was a bona fide paying job.)

Put your agreements in writing. At the end of this chapter you will find samples of order forms, commission and design agreements to use in your dealings, and sales agreements. It is vital that your rights,

your clients' rights, fees, billing procedures, and payment schedules be in writing.

COPYRIGHT

As a professional commercial artist, I see the commercial applications of the custom designs I do for clients. I sign each piece with a copyright notice (©), my name, and the year. The copyright is described by the Graphic Artists Guild as a "bundle of rights transferred separately. Rights that are not specified when sold remain the property of the artist." The copyright notice states that the layout and design are original, created by the artist, in the year marked on the paper. It tells other people that all rights to the artwork belong to the artist. The artwork cannot be reproduced by anyone without the artist's permission, nor can it be adapted in its recognizable form. Works that are not signed with a copyright notice are protected by common-law copyright, which protects the artist's rights to the work from the moment it is created. The work doesn't have to be published or registered with the copyright office, although registration further protects the artist by offering proof of the authenticity of the artist's claim to the work, allowing the artist to sue if the copyright is infringed upon, and entitling the artist to receive statutory damages. Artists have five years from the creation of a piece to file for a copyright. If a copyright is not filed, the work enters the public domain and is available to be copied by others. Signing your work with a copyright notice prevents future difficulties; it clearly states the artist's ownership of all the rights to possible commercial use of work. The client must understand that the transfer of reproduction rights is not implied in the transfer of ownership and conversely, the transfer of ownership is not implied in reproduction rights. The artist is selling a limited use of the artwork. The more rights to the artwork that are sold, the greater the compensation to the artist. Some buyers are surprised when the significance of the copyright is explained to them. They feel they are buying all rights to the artwork for one flat price. Upon payment, they believe they have the right to do whatever they want to do with the artwork—use it in books or on postcards—and keep the profits for themselves. If they bought "all rights," they would have to pay a considerably higher price than what one pays for one-use rights. The higher fee compensates the artist for the best revenue that could be earned from the work. The copyright notice entitles the artist to use the same design time after time.

Some "custom" artists use basically the same design or elements, and vary their arrangement from piece to piece so that clients believe they are getting an original design. As a self-advertised custom artist, I feel it is unethical to sell a client a custom design containing recognizable elements borrowed from a previous work of mine.

SETTING A FEE SCHEDULE

A number of financial factors should be considered in the pricing of original artwork. Though the actual price is negotiated between the artist and the client, the amount of work required, the complexity of the art, its intended use, and the artist's reputation, as well as the technique involved, must be taken into consideration. Some jobs might look simple but actually require a lot of time and effort. A freelance artist who works out of the home has many expenses that are easily overlooked: consultation fees, model fees, photocopies, books, research time, travel, shipping, materials, phone calls, electricity, rush jobs, and photography. All this must be considered in the price. The Graphic Artists Guild advises charging approximately fifteen percent of the overall cost for rush jobs.

Consultation with clients must be sufficiently compensated. Your time is money. If you spend two hours with a prospective client, you are "wasting" time that could have been spent working. You should have a rough idea of your hourly or daily rate, based upon your price level (if you charge $250 for a *ketubah* and it takes you twenty-five hours to complete, your hourly rate is $10 per hour and your daily rate, based upon a six-hour workday, is $60). If you spend two hours with a potential client, you are losing $20, particularly if he decides not to use you. If you have trouble getting clients to agree to pay this fee up front, include the cost of the consultation in the final sum, without explaining this to the client.

The final fee is negotiated between the two parties after all the facts are considered. Clearly outline the intended use of the artwork. State the terms of sale regarding transfer of the original or of specific reproduction rights (e.g., monograms, greeting cards). Calculate the fee accordingly and discuss it with the client before you accept the assignment and before you do any work. Quote one price that will cover all extraordinary costs plus one sketch of the final design. An additional fee is charged for every additional sketch and for additions or changes to the original design. Charge less for quick sketches and more for complex sketches—the fee will vary according to the time and expense involved. The price you charge organizations should not differ from the price you charge individuals, as the value of the art does not change. A calligrapher friend told me about a man who wanted a special price for a piece he was buying because he was acting as the agent of a synagogue. She told him that the price could not be changed. A year later a new client told her he had seen that same piece hanging in the man's house. So much for honesty!

State in writing that the deposit on the commission or sale is nonrefundable. The deposit can range from ten percent to fifty percent of the whole price.

A price quotation should be written out and presented to the

client before starting on the project. Keep a duplicate for your records. The quotation form, or purchase order, should be signed by the client before the project is started. For lengthy projects taking months to complete, arrangement can be made for partial payment. The fee you charge for monograms should be for the reproduction right only—sell the original at a higher price.

Never work on speculation, thereby giving the client something for nothing. Your time is worth money. You do not have the time to waste on a job you might not be paid for. A financial commitment from the client, a nonrefundable deposit, is the green light to pick up a pencil and draw.

Estimate your price by multiplying your hourly or per diem rate by the number of hours or days it will take you to do the work.

Deadlines that require you to work unreasonable hours, on weekends, nights, or holidays, should be taken into consideration when calculating your fees. Regardless of what the reasons are for the rush job, you should not be expected to produce acceptable work at your regular rates when a client expects to pay overtime for other services. A demand for a rush job shows lack of consideration for the artist's personal life and contempt for the creative process. The rush fee encourages more consideration for creative people and upgrades respect for the work.

Whatever financial arrangements are agreed to by the artist and client, the terms of the payment must be thoroughly understood. Calligraphers are professionals entitled to payment without unreasonable delay. Calligraphers are involved in work that requires individual creative effort and highly developed skills. Calligraphers have the right to negotiate fees and prices in accord with their professional services.

Work that has a good market increases in demand. An artist whose work is in demand can take advantage of the increased interest and raise prices. But be careful not to raise your prices too much all at once. It is demeaning to overprice oneself, thus putting an end to sales, then having to try to recapture the market by lowering one's prices. Raise your prices slowly and watch the public's reaction to your increases. Your goal should be to do fewer pieces for more money. I met a calligrapher who boasted about the number of commissions he had lined up. As it turns out, I am paid the same amount for one piece as he is paid for six. It means I can take on more jobs at a greater profit, or work half as hard as he does, and devote more time to other projects. Before you raise your prices, do some comparison shopping on similar works. Be objective about your own work and how it compares to other works on the market.

Not all clients are aware of the cost of artists' materials and the cost of living. They will try to bargain the price down or ask for more work for the same amount of money. If you feel you are being offered too low a price, thank the prospective client(s) for the interest in your

work, and say that you don't feel you can do the job for that price. I keep a list of calligraphers and their addresses, phone numbers, and prices handy for the rare occasion when I send a client elsewhere. I prefer to provide this service and be remembered positively. There is plenty of work to go around, so there is no need to feel you'll lose future clients if you hand out a list of your "competitors."

CONTRACTS

When selling artwork, regardless of whether it was bought "off the wall" or commissioned, an artist should insist on the use of a contract. The contract includes the date, the purchaser's name, address, and phone number, a description of the work, the price, a statement of copyright, and reservation of reproduction rights. The contract doubles as a receipt and should detail the terms of the sale.

Some artists prefer to have two contracts, one for the commissioning of the work and a second for the transfer of ownership. I have designed two such contracts, based on those detailed in *Tad Crawford's Legal Guide for the Visual Artist*, Allworth Press, 10 E. 23 Street, New York, NY 10010, 212-777-8395.

Contract 1: Order Form

When taking an order from a client, there is a lot of information that must be recorded. I have prepared a *job order form* that has simplified matters for me immensely. A properly prepared job order form organizes the order in which the information should be recorded, insuring that no aspect of the agreement is forgotten or misunderstood. In the case of detailed jobs, it would definitely seem in the best interest of all if such a form could be clearly prepared and initialed by your client.

The order form is a combination of the agreements of commission and transfer of ownership. It is arranged so the most important information is right at the top—the date ordered and the date to be delivered. A deadline is very important and must be met.

Contract 1: Order Form

Date ordered _____ Delivery date _____
Client's name, address, and phone number _____

Final price $ _____. Nonrefundable deposit $ _____

Occasion (wedding, bar/bat mitzvah, birth announcement, house
blessing, etc.)

Date of occasion: _____
 (day, month, year) English

 Hebrew (day, month, year)

Name(s) of principal(s): _____

 English Hebrew

Record status of each person (bride, groom, mother, father, grand- parents, baby, etc.).
Final dimensions: height _____ inches x width _____ inches.
Materials used _____.
Shape (square, rectangle, circle, octagon, ring shape, other) _____.
Border design (floral, geometric) _____.
 List the independent elements in the border (e.g., birds, animals, cherubs, crowns, scenic, etc.)
 and state whether it is a tight or loose design, open or closed, symmetrical or asymmetrical.
Other (e.g., wedding scene illustration) _____.
 Artist will not be held responsible for interpretation of design instructions unless the sketch has
 been approved by client.
Colors _____.
 Artist will not be liable for his/her interpretation of color or tone unless a color swatch has been
 provided.
Additional phrases requested by client: _____ English
 _____ Hebrew
Enlarged text (first letter, first word, phrase, names, etc.) _____.
 (e.g., marriage contracts, first line where bride's and groom's names appear, and/or last three
 words, hakol sharir vekayam) Enlarged text to be colored in (gold, red, etc.) _____.
Additional information:
 (e.g., Torah portion, date of birth, hour born, length and weight of baby, state or province of
 birth or event to use state flowers, birds, animals, etc., hobbies, likes, dislikes.)
Wedding contracts:
 It is the responsibility of the officiating rabbi to supply a completed ketubah form with the
 names, date, and country filled in according to the rabbi's specifications. The artist is not liable
 for errors in the text supplied by the rabbi.
 The ketubah or a photocopy of the text will be delivered prior to the wedding for the rabbi to
 approve. After final inspection and approval of the text by the rabbi, the artist will not be responsible
 for amending the text.
Replacement wedding contracts:
 The artist must be supplied with a photocopy of the original wedding contract. If the text is not
 available, the names, date of original wedding, city, and country must be supplied.
Final statement:

 1. All works are copyrighted by the artist and the year date. No works may be reproduced
 without the permission of the artist.
 2. All artwork is done on the highest quality cotton paper available (100 percent rag content).
 Parchment skin is available on special order at additional cost.
 3. Long distance calls, shipping, handling, and insurance charges are additional to the cost of
 the artwork.
 4. Overseas and Canadian buyers: payment must be made in U.S. currency.
 5. There is a fee for "rush" work to be completed and delivered in under thirty
 days.
 6. The artist reserves the right to include and delete elements discussed to
 accommodate the design and the cost.

Contract 2: Commission Agreement

The collector living at _____
telephone _____ acknowledges familiarity with the style
and work of the artist living at_____ .
The parties haveentered into this commission agreement on
this _____ of _____19_____ .

1. The artist, in consideration of the agreement contained
 herein, agrees to design for a fee in the range of $ _____ .
 a. approximate size
 b. materials and construction
 c. scope of artist's work
2. Receipt of $ _____ on_____ , 19 _____ for
 design work to be provided by artist after mutual signing of
 this contract.

Contract 3: Design Agreement

Receipt of $ _____ on _____ , 19 _____ for
design work to be provided by the artist after signing of this
agreement is hereby mutually acknowledged.

1. Artist agrees to provide reasonable sketch of work to collec-
 tor on or about _____ , 19 _____ . Collector has
 ten days after receipt of sketch to notify artist of change in
 design.
2. Artist provides maximum of _____ designs, or charges for
 additional sketches at an extra cost of $ _____ per
 hour.
3. If collector decides not to proceed with creation of work, all
 designs must be returned to the artist. The artist keeps the
 design fee and the agreement is terminated.
4. If the collector wishes to proceed with the work after
 selecting the design, the collector must sign a Commission of
 Original Art Agreement and pay one-third of the final fee.

The copyright notice states that all designs are the possession and
property of the artist. The artist keeps exclusive rights. The collec-
tor will not publicly display or copy the work. If the artist agrees to let
the collector use the art for commercial reasons, the artist receives
ten (10) percent of the revenue as a fee for its use.

Dated: _____ Dated: _____

_____ _____
 Artist Collector

Contract 4: Transfer of Ownership Agreement

On this day (collector) selected design and has given final approval for (artist) to proceed with creation of work of art.

Title: _____

Materials: _____

Approximate size: _____

Price: _____

Description of work: _____

Scope of artist's work: _____

Collector responsible for: _____

(Collector) agrees to pay artist one-third (1/3) of price of work at this time and approximately two-thirds (2/3) when completed. Artist gives collector five (5) days notice of delivery or pickup of work. Collector must then be ready to pickup and make final payment of $ _____ and sign original transfer of art. Sales tax of ____ % to be paid at this time.

Artist is only bound to use best aesthetic judgment to create the work according to style and intent of design. Artist is free to modify the design as work progresses. It is understood that it is not possible to create work exactly as the client envisions it, or as shown in the sketch.

Artist makes every effort to meet delivery date of _____ , 19 ____ but if artist fails to meet the date, artist is not responsible for special or consequential damages of doing so.

In the event of delayed payments, the collector will be charged 3% a month. Delay in payment allows for a delay in finishing work.

If collector decides he/she doesn't like the work or it is not meeting his/her expectations, collector shall immediately notify artist of termination.

Artist is entitled to retain payments made to date, as well as all rights to concept, design work itself, the right to complete, exhibit, and sell the work.

The transfer of work implies the artist keeps rights and title to the work until it is paid in full.

Dated: _____ Dated: _____

_____ _____
 Artist Collector

Contract 5: Transfer of Original Work of Art

Date: (day, month, year) _____

Sold to: (name, address, phone number) _____

Description of work (include size, colors, specific elements involved, such as "roses," "forget-me-nots"—"flower" is too general): _____

> Kohen's breastplate measuring _____ x _____ . Silver horns decorated with yellow ribbons coming down on either side bearing a red and blue geometric design. At bottom of opposing horns, name of son and daughter in Hebrew, and _____ . In breastplate, over stones, write replacement wedding contract text. At top of design between shoulder straps, pair of hands doing priestly blessing. Names of parents of B. and G. written in stretch between thumb and second finger of hands, G. on right, B. on left. Underneath hand for 32-colored gold, English and Hebrew date of original wedding done in circular design.

Media: watercolor and pen and ink.

Terms of payment: deposit upon delivery

(Artist will receive half the final price if piece is rejected, one-third final price if sketches rejected.)

Price _____

_____ _____
Purchaser Artist

This contract binds the purchaser's heirs and successors to the purchaser's obligation. It follows the purchaser and the purchaser's survivors for the life of the artist and the artist's spouse plus twenty-one (21) years.

The purchaser must receive permission from the artist to exhibit the work. The artist can show his/her work up to sixty (60) days once every five (5) years at no expense to the purchaser. The purchaser must receive written notice from the artist no less than one hundred and twenty (120) days before expected opening.

The purchaser will not allow the artist's work to be damaged, destroyed, or altered. If the work is damaged, the purchaser will consult the artist.

The artist's work cannot be rented without the artist's permission.

The artist will be kept informed of transfers of ownership. The ownership of the work is transferred between the undersigned persons and the new owner. The owner agrees to be bound by the terms of the contract dated between:

Artist:

Address:

Old owner: _____

New owner: _____ Date of transfer: _____

AUTHOR'S CONCLUDING WORDS

Students often discourage themselves from continuing in calligraphy because they set unrealistic amounts of practice time for their work sessions.

When you lead a busy life, trying to balance time for family, homemaking, job, and sundry other activities, it is discouraging to come away from a day or a week with the feeling that you didn't have a chance to do what you really wanted to.

While you can't make time slow down, you can control how you use it, making it work for you so you can accomplish realistic goals.

What to Practice

Decide what you really want to accomplish in your writing practice sessions. Organizing your time is essential. Trying to write all the letters of the alphabet in one session won't benefit you at all if you don't take the time to concentrate on the letter form and spacing. Since your goal is to learn to write the alphabet, analyzing letter shapes and practicing a few letters at a time is a more advantageous and satisfying use of your session. Don't just write the letter; write a good letter.

Use Your Time Effectively

First decide your priorities. Take out a sheet of paper and draw a line down the middle. On the left side, list all the projects you would like to accomplish in the near future. On the right side, list what you would like to accomplish today—the day-to-day practice that leads to your long-term goals. Your daily to-do list may include:

Practice letters *alef* through *heh*

Practice side-by-side spacing of two vertical strokes

Write phrase "_____ ."

Get a Calendar and Use It

Once you've decided what you want to do with your time, you have to figure out when to do it. If you don't arrange a practice time, you might keep putting it off.

Schedule your practice sessions and projects on the calendar and then assign a completion deadline. If you give yourself three weeks to complete a project, stick to your deadline, or finish it sooner. Be realistic about the time you set for yourself. Ten minutes of repetitious letter-writing is more than adequate. Sometimes big projects will seem so overwhelming you won't know where to begin. Take them one step at a time. Your long-range objective might be a wedding contract. A logical approach would be to divide the project into stages: writing, designing the art border, transferring the art border, inking in the art border, coloring the art border, and laying the gold color. Coloring the art border can be divided into painting the reds at one session, the blues at another session, and so on, until the picture is done.

Use Your Time Efficiently

You've listed your goals and scheduled the deadlines on your calendar, but instead of accomplishing your day's goals, you've puttered around.

Possibly the size of the task bothered you, so you spent your time on something menial like reading about calligraphy instead of doing it. Sometimes, avoiding the inevitable is good for you. It helps you shake the cobwebs from your head and relax. But sometimes, avoiding goals turns into a good old-fashioned case of procrastination. If you haven't accomplished anything in ten minutes at a practice or work session, you're procrastinating. Ease the load by dividing up the steps. If you set out to write the text in one session and it turns out to be more than you can handle, divide the writing into three or four sessions, five lines at a time.

Deadlines Are Deadlines

When you have to rush to meet a deadline, you tend to be flustered and distracted, and to make mistakes. The delays to correct

errors may set off a chain of lateness that will affect your whole calendar.

Instead of concentrating on the deadline day, focus on getting things moving toward your deadline. Prepare a list of what you have to do, estimate how long each step will take, when the job is due, and calculate your last starting date to meet the deadline without rushing.

Find Unused Time

Look at your schedule. You might discover ten minutes here or there that could be put to better use. Consider the time you spend on the phone, in a bus, in a car, or waiting for an appointment. If you carry a notepad and a pencil or a pen, you could use the time to practice writing or designing monograms or art borders. Write letters or paint while watching television. Five minutes here and there add up to a considerable amount of time.

Save Time for Yourself

Private time is a luxury that must be included in your weekly schedule. Set aside a few minutes to do something for yourself. Tell yourself, NO INTERRUPTIONS. The time you spend on yourself will boost your spirits so that the time you spend with others will be enjoyable.

Measure Your Progress

Grade yourself as you go along. Don't be afraid to judge your progress because you think it might be minimal. Whether or not you're conscious of it, it's human nature to grade yourself. For example, when you look at a friend's work and ask yourself, "Why don't my *alefs* look as good as hers?" you are measuring your progress.

Try a more constructive approach to evaluating your work. Cross off every to-do on your list as it is completed. At the end of each day, look at your list and note what you didn't do. If you didn't allow yourself enough time to accomplish everything, give yourself more time at the next session. At the end of each month, recheck your list. Add new goals and cross off the projects you've already completed. Though you may not have finished all your goals, chances are you accomplished more than you expected.

Enjoy Yourself

In lieu of lists, goals, and schedules, keep in mind that the primary goal of what you are doing is to make the most of your time. Enjoy yourself. Don't get so caught up in writing that it becomes a chore. If you're driving yourself too hard, loosen up a little bit.

Celebrate the completion of a goal by doing something for yourself; buy a new lettering or design book, treat yourself to a museum or art exhibit, buy an art magazine or a subscription you've always wanted. You deserve it.

APPENDIXES

THE KETUBAH

One of Judaism's primary sources of artistic tradition is the *ketubah*. The handwritten *ketubah*, or wedding contract, is experiencing a revival among young Jewish couples who are intrigued by the ancient tradition of personalized *ketubot*, written or decorated to order by scribes. The *ketubah*, which has been very much in use for over 3,000 years, is standard at Orthodox Jewish wedding ceremonies, but has been neglected by the less traditional branches of Judaism.

The *ketubah* is not a sacred document, it is a standard, legal contract with blanks where you plug in the names, dates, city, country of agreement, status of the bride, amount of dowry particular to each situation, and the witnesses' names. The *ketubah* is presented by the bridegroom to the bride as a legal agreement listing his obligations and responsibilities to her. It is designed to protect the widow, and to safeguard the wife's basic rights in marriage, and to discourage a husband from divorcing his wife for frivolous reasons. Divorce in Judaism is in the husband's hands. A husband may divorce his wife for any reason he feels is just, even if she merely burned the soup. In cases where the husband refuses to divorce his wife according to Jewish law

(allowing her to be free to remarry if she so chooses), communities have banded together to exert pressure on the reluctant husband to force him to give his wife a divorce when *she* asks for one, if her complaints of abuse have been verified.

The marriage ceremony includes the reading aloud of the marriage contract under the bridal canopy. The reading takes place immediately after the *kiddushin* (espousal) and before the *nissuin* (marriage). The *ketubah* is then handed from the husband to the wife. Jewish law does not require the *ketubah* to be read under the canopy, but it does state that the transfer of the document must take place before *yihud* (the symbolic seclusion of the bride and groom immediately after the wedding ceremony). The public reading of the *ketubah* was instituted to separate the betrothal blessing from the seven blessings of the wedding.

The conceptual origins of the marital agreement seem to date as far back in history as marriage itself. As societies and customs were becoming established, marital relationships were formalized. The need arose for a conventional definition of spousal rights and obligations. By the time the Jewish people stood at Mount Sinai to receive the Torah, strong customs had developed to control marital consanguinity. The Torah legitimatized the appropriate customs of marriage and revealed new laws that needed to be included.

As legal systems became more defined, a clear understanding of a husband's marital obligations evolved. The *bet din*, the Jewish court, had the power to enforce the obligations a man accepted at his wedding. Originally, the *ketubah* was a verbal agreement between the bride and groom. The proceedings were legitimatized by two qualified witnesses—males, 13 or older, not related to each other or the marital couple. These qualifications for witnesses are the same today. If at any time questions were raised concerning the marital obligations between husband and wife, the *bet din* would be called upon to rule. Court evidence could only be accepted from the two witnesses present at the wedding. The witnesses would recall in their testimony the exact conditions agreed to at the wedding. The court's judgment was based upon the witnesses' statements and the current situation. The court was unable to intervene in a marital dispute on behalf of either spouse if the original witnesses were deceased or unable to be found.

The language of the marriage contract was finalized around the time of the Babylonian exile. The need to commit the *ketubah* to paper became necessary to discourage husbands from pleading ignorance of the law. With the obligations set down on paper, husbands found it more difficult to shirk their duties. The ancient Aramaic text is still very much in use today; it is used in its entirety as the written contract for all Jewish weddings.

The *ketubah* is written in the form of a statement made by the witnesses, attesting to the fact that the husband has agreed to all

marital obligations. According to Jewish law, only the man has the right to a divorce on an arbitrary basis. The woman can force the termination of the marriage through the *bet din* if she can prove breach of contract. This weak link in the balance of power was strengthened by the transcription of what were originally verbal marital obligations, so there could never be any doubt as to what the groom agreed to. The witnesses sign the document, making it legally valid evidence. The signed document thus enables the court to act without the physical appearances of the witnesses at the hearing.

The first clause testifies that the husband has accepted all the conditions implied in marriage, even if they are not listed in writing. The second clause testifies that the bride has brought to the marriage a specified dowry and the groom has agreed to match the dowry, as is the custom. The third clause stipulates that, in the event of divorce or the husband's death, the conditions of the *ketubah* will be fulfilled by means of a lien on his estate.

The language and the dowry vary if the bride is not a virgin, or if she is divorced or widowed, is a convert to Judaism, or did not come from her father's house. There is also what is known as a *tosefta ketubah*, an additional contract. It is used when the couple desires additional and specific clauses added to their *ketubah*. If a couple has been living together without the benefit of a *ketubah*, they can complete the contract at a later date. If the *ketubah* has been lost or destroyed, or the couple wants to replace their original *ketubah*, a *ketubah d'irchese*, a replacement *ketubah*, is filled out. The *ketubah d'irchese* reaffirms the obligations the couple agreed to on their wedding day. The contract begins in the past, stating that "the groom who accepted unto himself, the obligations, at that date, at that time, in that place." The language switches to the present, stating that the groom is now reaccepting the obligations of the *ketubah* unto himself.

The creation of *mezzuzot, tefillin,* and Torah scrolls are governed by strict laws. They must be handmade on parchment, using social inks and writing papers. They must be written by a *sofer*, trained in the laws surrounding his profession. He must meet the religious qualifications and adhere to the format for writing letters, as described in the Sofer's Guide. The text must be devoid of embellishments. Women are prohibited from writing these texts.

Halakhah, traditional law, allows considerable freedom in the making of *ketubot*. A *ketubah* must be letter- and word-perfect. It can be done on paper, parchment vellum, fabric, glass, plastic, stone, or wood. It can be reproduced by hand, photocopying, mimeograph, silkscreen, or printing press as long as all the words and letters are recognizable. The words cannot be open to misinterpretation or broken into syllables. The script must be legible; the letters cannot touch one another. The scribes can be male or female; it is recommended that they have a working knowledge of Hebrew.

The development of art among Jewish communities can be studied in *ketubot*. The artistic motifs employed to decorate the marriage contracts reflect the countries and the period in which they were produced. Often, the decoration incorporated a phrase suited to the design, or of personal importance to the couple—biblical scenes with accompanying phrases, floral motifs, animals, and the like. "Adornment of a commandment," *hiddur mitzvah,* is an important concept in Judaism. *Hiddur mitzvah* encourages the use of beautiful objects when an object is required for the performance of a joyous celebration.

There are barely a handful of Hebrew calligraphers across Canada and the United States involved in the ancient practice of handwritten *ketubot.* Often, couples will commission a non-Jewish calligrapher who has no knowledge of Hebrew to write their *ketubah.* The couple then supplies the scribe with the copy of the Aramaic text, and the calligrapher, unfamiliar with the Hebrew letter forms, tries to the best of his or her ability to copy what is on the page. The calligrapher can innocently change the meaning of the words, thus rendering the *ketubah* null and void as a legal document. The woman who possesses a void *ketubah* will have difficulty collecting her dowry if the need ever arises.

To write the *ketubah,* you will need specific personal information about the couple and the occasion. I require that the information be supplied by the officiant of the ceremony, usually a rabbi, in *his* handwriting. If the officiant makes a mistake, it is his responsibility. If I make a mistake, it is my responsibility. You should request the phone number of the officiant who supplies the information so you can double-check the information or spelling. Ask for the bride and groom's Hebrew names; their fathers' Hebrew names, with Cohen כהן or Levi לוי after the fathers' names if they are of those tribes; add *Zikhrono Livrakhah* ז"ל after the name of a deceased father. Weddings that take place after *Tzait Hakohavim,* after the stars are in the sky, are dated the next Hebrew day. The *ketubah* must have the same date as the date of its signing by the witnesses. If the groom's table, *Hatan's Tish,* takes place at 4:00 P.M., the *huppah* is scheduled for 7:30 P.M., and sundown is at 5:30 P.M., the *ketubah* must be signed before 5:30 P.M. The exact time of sundown, which varies throughout the year, can be verified in a Jewish calendar. The masculine form of the Hebrew number is used for the day of the week; the feminine form is used for the day of the month.

A hundred-and-fifty-year calendar, copyright © 1963 by M. Greenfield, gives the corresponding Hebrew date to an English date and Hebrew year. It does not provide the spelling and proper language for the day, month, and year, but it's useful for relating English and Hebrew dates, holidays, *sidrahs,* and *haftorahs.* You will need the

proper spelling of the name of the city and country in which the wedding is taking place. To be sure of the correct spelling, refer to the spellings as they appear on *gittin,* divorce documents. Access to *gittin* is through rabbinical courts.

Ketubot must be signed in the same way that *gittin* are signed—one signature on top of the other signature, not side by side:

The full names of the bride and groom (given name and father's name) are written at the beginning and at the end of the *ketubah.* In all other places, only the given names of the bride and groom need appear.

The completion of the *ketubah* by the adding of the word *v'kaninah* וקנינא , to be acquired, symbolizes the groom's acceptance of the responsibilities of a Jewish husband unto himself, "according to the law of Moses and Israel," like all other Jewish husbands. *V'kaninah* is derived from the word *kinyan,* acquisition. It is customary to leave out all or part of the word from the written text and fill it in at the groom's table, the *hatan's tish.* The rabbi transfers an object, usually a handkerchief or a pen, to the groom and asks him if he accepts the obligations of the *ketubah.* The groom returns the object to the rabbi, answering yes. The rabbi writes in the word and the witnesses validate the transaction by signing at the bottom of the document in the areas marked נאום—עד (name _____ witness). Every rabbi has his own preference as to how to deal with the word וקנינא . Some prefer the whole word left out, some prefer it penciled in, others prefer one letter or part of one letter left out. I prefer to have the word written in by the rabbi so people will ask why the word is different from the rest of the text. I was taught that if you are going to make a "mistake," you should make sure it looks deliberate, not like an afterthought.

When writing the *ketubah* text, minimize errors by crossing off each word as you complete it. Avoid writing in the book you are copying from. Photocopy the text being copied and scratch out the finished words with a pencil.

THE KETUBAH

בְּ _____ 1 בְּשַׁבַּת _____ 2 בְּחֹדֶשׁ _____ 3 שְׁ _____
חֲמֵשֶׁת אֲלָפִים _____ 4 לִבְרִיאַת עוֹלָם לַמִּנְיָן
שֶׁאָנוּ מוֹנִין כָּאן _____ 7 בִּמְדִינַת _____ 6 אֵיךְ הֶחָתָן
_____ 8 אָמַר לָהּ לְ _____ 10 בַּת _____ 11 הֱוִי לִי לְאִנְתּוּ
כְּדַת מֹשֶׁה וְיִשְׂרָאֵל וַאֲנָא אֶפְלַח וְאוֹקִיר וְאֵיזוֹן וַאֲפַרְנֵס
יָתֵיכִי לֵיכִי כְּהִלְכוֹת גּוּבְרִין יְהוּדָאִין דְּפָלְחִין וּמוֹקְרִין וְזָנִין
וּמְפַרְנְסִין לִנְשֵׁיהוֹן בְּקוּשְׁטָא וְיָהֵבְנָא לֵיכִי _____ 12
וּמְזוֹנַיְכִי וּכְסוּתַיְכִי וְסִפּוּקַיְכִי _____ 10
וּמֵיעַל לְוָתֵיכִי כְּאוֹרַח כָּל אַרְעָא וְצָבִיאַת מָרַת
_____ 9 דָּא וַהֲוָת לֵיהּ לְאִנְתּוּ וְדֵין נְדוּנְיָא דְּהַנְעֲלַת לֵיהּ מִ _____
לֵיהּ מִ _____ 13 בֵּין בְּכֶסֶף בֵּין בְּזָהָב בֵּין בְּ _____ גַּבְשׁוּשִׁין
בְּמָאנֵי דִלְבוּשָׁא בְּשִׁמּוּשֵׁי דִּירָה _____ 14 וּבְשִׁמּוּשֵׁי דְעַרְסָא
הַכֹּל קִבֵּל עָלָיו _____ 7 חֲתָן דְּנָן _____ זְקוּקִים
בְּסֹף צָרוּף וְצָבֵי _____ הֶחָתָן דְּנָן וְהוֹסִיף לָהּ
מִן דִּי _____ לָהּ עוֹד _____ 15 זְקוּקִים כֶּסֶף צָרוּף אַחֵרִים
כְּנֶגְדָן סַךְ הַכֹּל _____ 16 זְקוּקִים כֶּסֶף צָרוּף וְכָךְ
אָמַר _____ 7 חֲתָן דְּנָן אַחֲרָיוּת _____ וְהוֹסָפְתָּא
דָּא צַדְיוּנָא דֵּין _____ וְהוֹסָפְתָּא דָּא קַבֵּלִית עֲלַי וְעַל יָרְתַי
בַּתְרַאי לְהִתְפְּרַע מִן כָּל שְׁפַר אַרְ _____ נִכְסִין וְקִנְיָנִין
דְּאִית לִי _____ תְּחוֹת כָּל שְׁמַיָּא דִּקְנַאי וּדְעָתִיד אֲנָא
לְמִקְנָא נִכְסִין דְּאִית לְהוֹן אַחֲרָיוּת וּדְלֵית לְהוֹן
אַחֲרָיוּת כֻּלְּהוֹן יְהוֹן אַחֲרָאִין וְעַרְבָאִין לְפָרוֹעַ מִנְּהוֹן שְׁטַר
כְּתֻבְּתָא דָּא נְדוּנְיָא דֵּין וְתוֹסַפְתָּא דָּא מִנַּאי וַאֲפִלּוּ מִן _____ מִן
גְּלִימָא דְעַל כַּתְפַּאי בְּחַיַּי וּבָתַר חַיַּי מִן יוֹמָא דְנַן וּלְעָלַם
וְאַחֲרָיוּת שְׁטַר כְּתֻבְּתָא דָּא נְדוּנְיָא דֵּין וְתוֹסַפְתָּא דָּא קַבֵּל
עָלָיו _____ 7 חֲתָן דְּנָן כְּחֹמֶר כָּל שִׁטְרֵי כְתֻבּוֹת
וְתוֹסָפוֹת דְּנַהֲגִין בִּבְנַת יִשְׂרָאֵל הָעֲשׂוּיִין כְּתִקּוּן חֲכָמֵינוּ זִכְרוֹנָם
לִבְרָכָה דְּלָא כְּאַסְמַכְתָּא וּדְלָא כְטוֹפְסֵי דִּשְׁטָרֵי מִן _____ 17
בְּ _____ 7 חֲתָן דְּנָן לְמָרַת _____ 10 בַּת _____ 11
דָּא עַל כָּל מַה דִּכְתוּב וּמְפֹרָשׁ לְעֵיל _____ 9
בְּמָנָא דְכָשֵׁר לְמִקְנָא בֵּיהּ וְהַכֹּל שָׁרִיר וְקַיָּם
נְאֻם _____ 18 עֵד
נְאֻם _____ 18 עֵד

Here is a translation of the *ketubah* text (used for first-time brides):

On the ___1___ day of the week, the ___2___ day of the month ___3___ in the year ___4___ since the creation of the world, the era according to which we are accustomed to reckon, here in the city of ___5, 6___ (name of city, state, and country), how ___7___ (groom's name), son of ___8___ (father's name), said to this ___9___ ___10___ (name of bride), daughter of ___11___ (name of father): Be thou my wife according to the Law of Moses and Israel, and I will cherish, honor, support, and maintain thee in accordance with the custom of Jewish husbands who cherish, honor, support, and maintain their wives in truth. And I herewith make for thee the settlement of ___12___ , which belongs to thee according to the law of Moses and Israel, and (I will also give to thee) thy food, clothing, and necessaries, and live with thee as husband and wife according to universal custom. And ___10___ (name of bride), this ___9___ consented and became his wife. The wedding outfit that she brought unto him from ___13___ , in silver, gold, valuables, wearing apparel, house furniture, and bedclothes, all this ___7___ (name of bridegroom), the said bridegroom, accepted in the sum of ___14___ and ___7___ , the bridegroom, consented to increase this amount from his own property with the sum of ___15___ , making in all ___16___ . And thus said ___7___ (name of bridegroom), the bridegroom: "The responsibility of this marriage contract, of this wedding outfit, and that of my heirs after me, so that they shall be paid from the best part of my property and possession that I have beneath the whole heaven, that which I now possess or may hereafter acquire. All of my property, real and personal, even the mantle on my shoulders, shall be mortgaged to secure the payment of this marriage contract, of the wedding outfit, and of the addition made thereto, during my lifetime and after my death, from the present day and forever." ___7___ (name of bridegroom), the bridegroom, has taken upon himself the responsibility of this marriage contract, of the wedding outfit, and the addition made thereto, according to the restrictive usages of all marriage contracts, and the additions thereto made for the daughter of Israel, in accordance with the institution of our Sages of Blessed Memory. It is not to be regarded as a mere forfeiture without consideration or as a mere formula of a document. We have followed the legal formality of a symbolic delivery ___17___ (*kinyan*) between ___7___ (name of bridegroom), the son of ___8___ (groom's father's name), and the bride ___10___ (name of bride), the daughter of ___11___ (bride's father's name), this ___9___ , and we have used a garment legally fit for this purpose, to strengthen all that is stated above. And everything is valid and confirmed.

Attested _____18_____ (Witness)
Attested _____18_____ (Witness)

HEBREW TRANSLATION OF KETUBAH

Fill in Appropriate Blanks

1. Day of the week

בְּאֶחָד, בְּשֵׁנִי, בִּשְׁלִישִׁי, בִּרְבִיעִי, בַּחֲמִישִׁי, בַּשִׁשִׁי

2. Day of the month

בְּאֶחָד לַחֹדֶשׁ, בִּשְׁנֵי יָמִים לַחֹדֶשׁ, בִּשְׁלֹשָׁה יָמִים, בְּאַרְבָּעָה
יָמִים, בַּחֲמִשָּׁה יָמִים, בְּשִׁשָּׁה יָמִים, בְּשִׁבְעָה יָמִים, בִּשְׁמֹנָה
יָמִים, בְּתִשְׁעָה יָמִים, בַּעֲשָׂרָה יָמִים, בְּאַחַד עָשָׂר יוֹם, בִּשְׁנֵים
עָשָׂר יוֹם, בִּשְׁלֹשָׁה עָשָׂר יוֹם, בְּאַרְבָּעָה עָשָׂר יוֹם, בַּחֲמִשָּׁה
עָשָׂר יוֹם, בְּשִׁשָּׁה עָשָׂר יוֹם, בְּשִׁבְעָה עָשָׂר יוֹם, בִּשְׁמֹנָה עָשָׂר
יוֹם, בְּתִשְׁעָה עָשָׂר יוֹם, בְּעֶשְׂרִים יוֹם, בְּאֶחָד וְעֶשְׂרִים ——— יוֹם,
בִּשְׁנַיִם וְעֶשְׂרִים יוֹם, בִּשְׁלֹשָׁה וְעֶשְׂרִים יוֹם, בְּאַרְבָּעָה וְעֶשְׂרִים יוֹם,
בַּחֲמִשָּׁה וְעֶשְׂרִים יוֹם, בְּשִׁשָּׁה וְעֶשְׂרִים יוֹם, בְּשִׁבְעָה וְעֶשְׂרִים ——— יוֹם,
בִּשְׁמֹנָה וְעֶשְׂרִים יוֹם, בְּתִשְׁעָה וְעֶשְׂרִים יוֹם, בִּשְׁלֹשִׁים יוֹם
לַחֹדֶשׁ _____ שֶׁהוּא רֹאשׁ חֹדֶשׁ

3. Month

תִּשְׁרֵי, חֶשְׁוָן, כִּסְלֵו, טֵבֵת, שְׁבָט, אֲדָר א', אֲדָר ———— ב'
נִיסָן, אִיָּר, סִיוָן, תַּמּוּז, אָב, אֱלוּל

4. Year

5. City, country where wedding is being held

6. Country

7. Groom's Hebrew name(s)

8. Groom's father's Hebrew name(s), including Levi or Cohen, or deceased

הַכֹּהֵן ה ָלֵּוִי עַ ה"ל ז"ל

9. Bride's status (first marriage, widow, divorcee, convert, or other)

בְּתוּלְתָּא אַרְמַלְתָּא בְּתוּלְתָּא
גִּיּוֹרְתָּא אִיתְּתָא מְתָרְכְתָּא

10. Bride's Hebrew name(s)

11. Bride's father's Hebrew name(s), including Levi or Cohen, or deceased

הַכֹּהֵן ה ָלֵּוִי עַ ה"ל ז"ל

12. Involves dowry; select appropriate line

מֹהַר בְּתוּלְתָּא כֶּסֶף זוּז מָאתָן דְּחָזֵי לִיכִי מִדְּאוֹרַיְתָא
כֶּסֶף אַרְמַלְתְּהִי זוּז מְאָה דְּחָזֵי לִיכִי מִדְּרַבָּנָן
כֶּסֶף מְתָרְכְתָהִי זוּז מְאָה דְּחָזֵי לִיכִי
כֶּסֶף זוּז מְאָה דְּחָזֵי לִיכִי

13. If father is or is not deceased

אֲבִיהָ נִשֵּׂא

14. Involves amount of dowry; select appropriate word

צְזוּזֵֽ־ל : בְּמָאָה : אחרת : בַּחֲמִישׁ׳ן

15. Involves dollar amount of dowry; select appropriate word

בְּזוּזֵֽ־ל : מֵאָה : אחרת : חֲמִשׁ׳ן

16. Involves dollar amount of dowry; select appropriate word

בְּזוּזֵֽ־ל : מֵאתַּיִם : אחרת : מֵאָה

17. Part or whole of word left out, according to officiant's direction; filled in by officiant under the wedding canopy

וּקְנֵֽינָא

18. Witnesses' signatures

The phenomenon of "anniversary wedding contracts" is an abuse of tradition. Rabbinic authorities suggest that when original wedding contracts are redone on the occasion of an anniversary, the original *ketubah* witnesses' signatures should not be forged. They recommend drawing a line through the spots where the witnesses would sign, indicating that it is a fine art piece and not the original wedding contract.

SUGGESTIONS FOR USE OF HEBREW CALLIGRAPHY

Ketubot

Shivvitim

Mizrahim

Favorite Hebrew verses

Quotations

Wedding invitations, bar and bat mitzvah invitations, birth announcements

Naming of a daughter certificate

Brit Milah certificate

Pidyon Haben certificate

Rosh Hashanah cards

Note cards, bookplates

Humashim

Haggadot

Megillot

Torah portions for bar or bat mitzvah

Verses, hymns, proverbs, psalms, selections from prayer books

Astrological charts, calendar, Omer calendars

Amulets

Dedications

Commandments

Family trees

Certificates

Testimonies

Scrolls of Honor and Scrolls of Memory

Speeches

Monograms (on invitations for weddings, bar/ bat mitzvah, birth cards)

Place cards, programs, menus, catalogues, personal notes

Wimple (Torah binder)

Rabbinic/ yeshivah graduation (*Morenu/* our teacher) certificates

Huppot

Tombstones

Hallah covers

Sukkah decorations

Simchat Torah decorations/ flags, etc.

DIRECTIONS OF STROKES FOR
THE RIGHT- AND LEFT-HANDED
CALLIGRAPHER

Right-handed

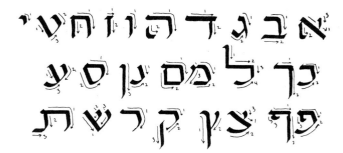

Direction of Strokes for the Right-Handed Calligrapher

Left-handed

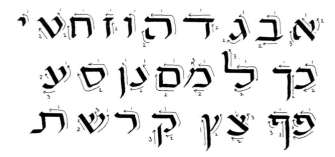

Direction of Strokes for the Left-Handed Calligrapher

Note: The natural pen-writing motion is a pulling action of the nib toward the hand. If a left-handed calligrapher were to follow the direction of strokes indicated for the rightie, he would be pushing the pen nib against the natural motion of strokes, tiring the hand unnecessarily.

Hebrew cursive

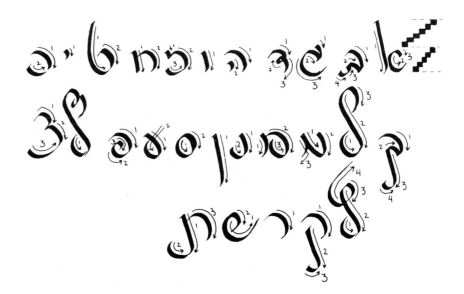

THE ALPHABET

Letter Name in English		Numerical Value	Pronunci- ation	Hebrew Letter		Hebrew Name
Sephardi	Ashkenazi			Square	Cursive	
Alef	Alef	1	silent	א		אָלֶף
Bet, vet	Bays, vays	2	(v), (b)	בּ,ב		בֵּית,בֵית
Gimel	Gimel	3	(g, gh)	ג		גִּמֶל
Dalet	Daleth	4	(d, dh)	ד		דָלֶת
Heh	Heh	5	(h)	ה		הֵא
Vav	Vav	6	(w,v)	ו		וָו
Zayin	Zayin	7	(z)	ז		זַיִן
Het	Chess	8	(ch)	ח		חֵית
Tet	Tess	9	(t)	ט		טֵית
Yod	Yod	10	(y)	י		יוֹד
Kaf	Kaf	20	(kh, k)			כַּף,כָף
Kaf sofit	Kaf sofit		(kh)	כּ,כ,ךְ		כָף סוֹפִית
Lamed	Lamed	30	(l)	ל		לָמֶד
Mem	Mem			מ		מֵם
Mem sofit	Mem sofit	40	(m)	ם		מֵם סוֹפִית
Nun	Nun	50	(n,n)	נ		נוּן
Nun sofit	Nun sofit		(n,n)	ן		נוּן סוֹפִית
Samekh	Samekh	60	(s)	ס		סָמֶך
Ayin	Ayin	70	(silent)	ע		עַיִן
Pe, Pheh	Pe, Pheh	80	(p, ph)	פּ,פ		פֵּא,פֵא
Pe/pheh sofit	Pe/pheh sofit			ף		פֵּא סוֹפִית
Tzadi	Tzadi	90	(ts)	צ		צָדִי
Tzadi sofit	Tzadi sofit			ץ		צָדִי סוֹפִית
Kuf	Kuf	100	(k)	ק		קוּף
Resh	Resh	200	(r)	ר		רֵישׁ
Shin, sin	Shin, sin	300	(sh, s)	שׁ שׂ		שִׁין,שִׂין
Tav, tav	Tav, tav	400	(th, t)	תּ,ת		תָּו,תָו

Hebrew letters are pronounced according to the Sephardi pronunciation, the official pronunciation of Israel. The Hebrew letters, in the mnemonic b'gad k'fat, have a dot, dagesh, inside them when they appear at the beginning of a word or syllable, and when there is no vowel sound immediately preceding them. The dagesh gives the letters a hard sound.

1. Guttural (pronounced in the throat) alef, heh, het, ayin

 ע ח ה א

2. Palatal (pronounced on the palate) *gimel, yod, kaf, kuf, resh*

ר ק כ י ג

3. Lingual (pronounced with the tongue) *dalet, tet, lamed, nun, tav*

ת נ ל ט ד

4. Sibilant (pronounced with teeth) *zayin, samekh, tzadi, shin*

ש צ ס ז

5. Labial (pronounced with lips) *bet, vav, mem, pe*

פ מ ו ב

Vowels

Hebrew vowels are placed either above or below consonants, with the exception of the *shurug* () שׁוּרוּק and *holam* () חוֹלָם , which are placed to the left of the consonant. Each vowel, when combined with one or more consonants, forms a syllable.

English		Hebrew	
Short Vowels	Pronunciation	Vowel Sign	Short Vowels
Pattah	(a) father	ָ	פַּתָּח
Kubbutz	(oo) soon	ֻ	קֻבּוּץ
Hiriq hasser	(ee) feet	ִ	חִירִיק חָסֵר
Segol	(e) pet	ֶ	סֶגּוֹל
Kamats katan	(o) cord	ָ	קָמַץ קָטָן
Long Vowels			
Holam maleh	(o) cord	וֹ	חוֹלָם מָלֵא
Holam hasser	(o) cord	ֹ()	חוֹלָם חָסֵר
Shuruk	(oo) soon	וּ	שׁוּרוּק
Hirik maleh	(ee) feet	ִי ,()	חִירִיק מָלֵא
Tsere maleh	(e) they	()	צֵירֵי מָלֵא
Tsere haser	(e) they	()	צֵירֵי חָסֵר
Kamatz gadol	(a) father	()	קָמַץ גָּדוֹל
Half Vowels			
Sheva na	Silent	()	שְׁוָא נָע
Hataf pattah	(a) shorter than a in father	()	חֲטַף פַּתָּח
Hataf segol	(e) shorter than e in pet	()	חֲטַף סֶגּוֹל
Hataf kamatz	(o) cord	()	חֲטַף קָמַץ

For the most part, Hebrew textbooks, newspapers, and journals are typeset without vowels (*nekudot*) נקדות . Vowels are included in literature meant for the beginning reader, to facilitate reading. Vowels can be written with the calligraphic pen or dipped in with a technical pen. I find that the technical pens #0, #1, or #2 give uniform, distinct shapes that are easier to recognize than those vowels dipped in with a nib pen.

THE HEBREW ALPHABET
AND ROMAN LETTER FORMS

The Hebrew alphabet has had a distinct influence on the Roman alphabet, as we see here.

Historically, *alef* has always been at the head of the alphabet. The Phoenicians called it *alef;* the Greeks called it *alpha.* The lower-case letter **a,** as we know it, developed from the uncial and Caroline forms.

Bet also kept its accustomed place in the alphabetical sequence. *Alef,* and *bet,* or *alpha* and *beta* in Greek, comprise the word "alphabet."

Gimel is the third letter in the ancient Semitic and Roman alphabets. The letter **c** was used for both **g** and **k**. The **g** became silent after the sixth century.

Dalet, in the Semitic alphabet, was adopted by the Greeks as *delta*.

Heh, a constant in the Semitic alphabet, has the sound of **h**. It became *epsilon* in the Greek alphabet.

Vav, the sixth character of the Semitic alphabet, has the sound of **v**. *Vav* or *digamma*—a secondary form known to the Greeks—was eventually dropped from the Greek alphabet. The letter **f** assumed its form from the Roman alphabet.

Zayin has the same sound as the English character **z**.

Het, which has kept its position in the ancient and modern alphabets as the eighth character, is pronounced like the **ch** in the Scottish word "loch."

Tet has the letter **t** sound.

Yod, the tenth character, has the constant sound of **y**. In ancient Greek it sounded very much like it does today. It represents the letters **i** and **j** in Latin. **J** has no equivalent in the Semitic alphabet. It was a consonantal sound of the letter **i** added in the Middle Ages.

The letter *kaf* appeared in the Greek alphabet and was passed into the Latin alphabet in pretty much the same form it has today. Its sound, a hard **k**, has not varied in the transition.

The middle letter of the Semitic alphabet, the *lamed,* developed into the Greek *lambda.* The vertical stem stroke in the English letter **l** was oblique in the Etruscan and Latin forms.

Mem occupies the thirteenth position in both the Semitic and English alphabets. It was *mu,* the twelfth letter in the Greek alphabet.

Like **m** and **n**, the letters *mem* and *nun* have always been closely related.

Samekh is the fifteenth letter of the Hebrew alphabet. It evolved from a letter with three horizontal strokes crossed by a vertical downstroke to the horizontal by the curved bottom. Its sound duplicates the letter **s**.

The letter *ayin* is a consonant sound. It was adapted by the Greeks to represent the short and long vowel **o**.

The Semitic character *pe* was represented in the Greek alphabet by the character *pi;* in the Roman alphabet, the bowl was closed. It has survived in this form to the present.

Tzadi, pronounced "ts," has no single character equivalent in the English alphabet.

The Semitic *kuf* was adopted by the Greeks, and has changed little from the Greek form to its present form in the Roman alphabet.

The Semitic *resh* has the same sound as the English letter **r**. The letter appeared first in reverse without the tail; the tail was added later by the Greeks.

Shin, the twenty-first letter of the Semitic alphabet, was the eighteenth character in the Greek and Etruscan alphabets, and is nineteenth in the Roman alphabet.

Tav is the final letter in the Semitic alphabet. The letter **t** assumed its present form in the Greek and Roman alphabets.

The letter **u** originally stood for both vowel and consonant sounds. Later it evolved into a separate character.

V also represented both vowel and consonant in the Roman alphabet; it did not change until the Middle Ages.

W was not added until the eleventh century. Its sound duplicates **u** or **v**. It was originally formed from two **vs**.

W

X was adopted from the Greek alphabet by the Romans. It combines the sound "**ks**" into a single letter.

X

The letters **y** and **z**, *yod* and *zayin,* were borrowed from the Romans for use in certain Greek words that they adopted after the fall of Greece.

BIBLIOGRAPHY

Adams, A. (1968). *The Negative*. New York: Morgan and Morgan Inc.

——— (1968). *The Print*. New York: Morgan and Morgan Inc.

Anderson, D. M. (1969). *The Art of Written Forms*. New York: Holt, Rinehart and Winston.

Baler, Y. L. (1976). *Jewish Life in Art and Tradition*. New York: G. P. Putnam and Sons.

Barasch, M. *Scripta Hierosolymitana*, vol. 24. Jerusalem: Magnes Press, Hebrew University.

Blake, W. (1979). *The Watercolor Painting Book*. New York: Watson Guptill Publications.

——— (1979). *The Oil Painting Book*. New York: Watson Guptill Publications.

——— (1970). *The Acrylic Painting Book*. New York: Watson Guptill Publications.

Camp, A. (1978). *Pen Lettering*. Leicester, England: Dryad Press.

Chamberlain, B. (1975). *The Artist's Guide to His Market*. New York: Watson Guptill Publications.

Crawford, T. (1977). *Legal Guide for the Visual Artist*. New York: Allworth Press.

Diringer, D. (1968). *The Alphabet*, vol. 1–vol. 22. Oxford: Hutchinson of London, Alden Press.

Encyclopedia Judaica (1974). Jerusalem, Israel: Keter, Jerusalem Ltd.

 Vol. 2, pp. 46, 554, 674–745, 747–749. Vol. 3, pp. 241, 305, 521, 995. Vol. 4, p. 709. Vol. 5, p. 1227. Vol. 7, pp. 578, 754. Vol. 8, pp. 1, 438. Vol. 10, pp. 424, 635, 669, 1133, 1347, 1367. Vol. 11, p. 1297. Vol. 12, pp. 189, 1255, 1272. Vol. 13, p. 194. Vol. 14, pp. 80, 622, 767. Vol. 15, pp. 700, 836, 1029, 1480. Vol. 16, pp. 367,654ff, 791, 843, 943, 1335.

Gaster, M. (1901). *Hebrew Illustrated Bibles of the IX and X Centuries*. London: Harrison and Sons.

Goldin, H. E. (1956). *Hamadrikh, The Rabbis' Guide*. New York: Hebrew Publishing.

Gordis, R., and Davidowitz, M. (1975). *Art in Judaism*. New York: National Council on Art in Jewish Life and Judaism.

Johnston, E. (1945). *Writing and Illuminating and Lettering*. New York: Pitman Publishing Co.

Landmann, M. (1977). *Neugestaltung der Hebraischen Schrift*. Germany: Bruvier Verlag Herbert Grundmann Bok.

Landsberger, F. (1946). *A History of Jewish Art*. Cincinnati: Hebrew Union College.

McCann, M. (1975). *Health Hazards for Artists*. New York: Foundation for the Community of Artists.

McCarter, P. K., Jr. (1975). *The Antiquity of the Greek Alphabet and the Early Phoenician Scripts*. Cambridge, MA: Scholars Press for Harvard Semitic Museum.

Mayer, R. (1970). *The Artist's Handbook of Materials and Techniques*. New York: Viking Press.

————. (1967). *Midroshei Hagnizah*. Israel: K'tav V'Sofer.

Neubaur, A. (1886). Facsimiles of Hebrew manuscripts in the Bodleian Library. London: Oxford University Press.

Picker, F. (1974). *Zone VI Workshop*. New York: Amphoto Publishing Co.

Reinhardt, E., and Rogers, H. (1958). *How to Make Your Own Picture Frames*. New York: Watson Guptill Publications.

Roth, C. (1971). *Jewish Art. An Illustrated History*, rev. B. Narkiss. New York: New York Graphic Society.

Sirat, C. (1985). *Écriture et Civilisations*. Paris: Institut de Recherce et d'histoire des Textes—Études de Paleographie Hebraique.

Waxman, M. (1930). *History of Jewish Literature*, vol I. New York: Bloch Publishing Co.

Zerbe, A. S. (1911). *The Antiquity of Hebrew Writing and Literature*. Cleveland: Central Publishing House.

INDEX